SELECTED PAINTINGS AT

The NORTON SIMON MUSEUM

PASADENA, CALIFORNIA

Introduced by
FRANK HERRMANN

Scala/Philip Wilson Publishers Ltd
LONDON AND NEW YORK

©Philip Wilson Publishers Ltd and
Summerfield Press Ltd 1980

Photographic copyright © 1980 Norton Simon and
the Trustees of the Norton Simon Museum at Pasadena,
the Norton Simon Inc. Foundation and the Norton Simon Foundation

First published in 1980 by Philip Wilson
Publishers Ltd and Summerfield Press Ltd

Designed by Paul Sharp

Produced by Scala Istituto Fotografico Editoriale, Firenze
Filmset in England by Jolly & Barber Ltd, Rugby
Printed in Italy

ISBN 0-85667-093-6 Pbk
ISBN 0-85667-094-4 Hdbk

AMILCARE PIZZI ARTI GRAFICHE S.p.A.
CINISELLO B. (MILANO – ITALIA) – 1980

Front cover: Rembrandt van Rijn,
*Portrait of the Artist's Son, Titus, c.*1645–50

Back cover: Dieric Bouts,
*The Resurrection, c.*1455
Tempera on linen 90 × 74.3cm

Introduction

It is not often that a museum has been created by a single man. It is even more unusual to find a museum that covers so many major periods of European art and contains great examples of the relevant master's work where each one has been chosen by a single man. Perhaps the most surprising thing is that this should have been achieved in the last quarter of the present century, a time when the art market has burgeoned and the competition for outstanding works of art has increased as never before. It has taken unbending determination, creative thinking and a marvellous seeing eye to bring it all together, and having done so to blend it into a harmonious whole in a refreshingly simple setting. It is an achievement that is unlikely to recur on such a scale.

Mr Simon started his collection conventionally enough with the purchase of three Impressionist paintings. As his collection grew he soon became intrigued by the workings of the art world. He gained a remarkable inside knowledge of its complexity and internationalism when in 1964 he bought the famous art dealing firm which Lord Duveen had started late in the nineteenth century. He found he had acquired a group of major paintings, sculptures and tapestries and a basement full of neglected and forgotten puzzle pieces, many of which occasioned long and diligent study. But most important, there were mountains of documentation and years of correspondence, particularly between Lord Duveen, his staff and his principal artistic adviser, Bernard Berenson. This archive demonstrated the essential relationship between expertise and dealing, and the nature of the relationship that Duveen had with many of the major scholars of his day; and it confirmed Mr Simon's predisposition always to seek the widest range of expert advice before making an acquisition.

But it is ultimately personal connoisseurship that shapes a collection. One of the difficulties when acquiring works of art today which are three, four or five

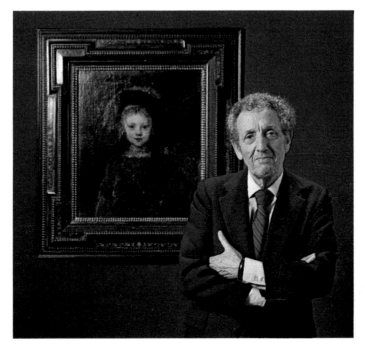

Mr Simon with Rembrandt's *Portrait of the Artist's Son, Titus*

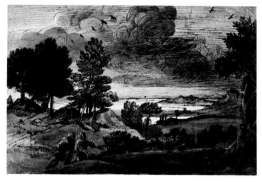

Claude Gellée, called Le Lorrain, 1600–82
Heroic Landscape
1655–8 Pen, deep brown wash, also grey
wash for the middle distance, white
heightening in the foreground 22.2 × 33cm

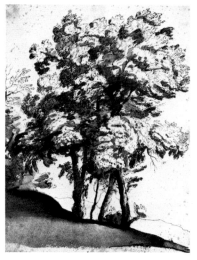

Claude Gellée, called Le Lorrain,
1600–82 *Landscape with the
Magdalen*
1675 Pen, brown and grey wash,
some white heightening
19.1 × 14.8cm

Claude Gellée, called Le Lorrain,
1600–82 *A Group of Trees in
Sunlight*
1633 Pen, brown wash
24.8 × 19.1cm

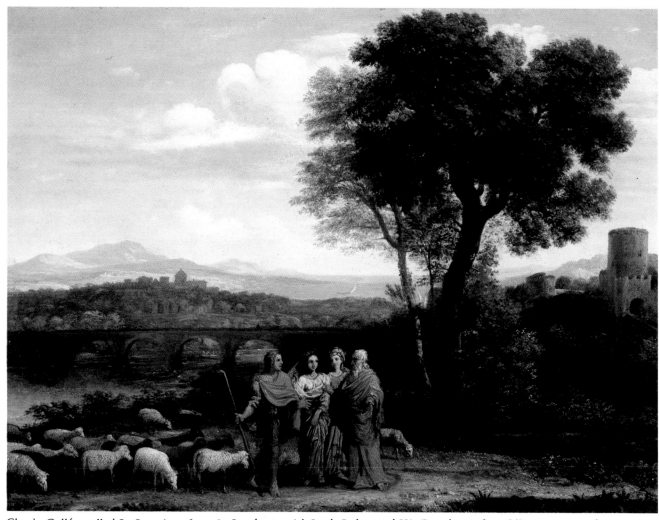

Claude Gellée, called Le Lorrain, 1600–82 *Landscape with Jacob, Laban and His Daughters* 1659 Oil on copper 26.7 × 35.1cm

4

centuries old, is to establish beyond all reasonable doubt the identity of their creators and the true condition and beauty of the objects. There are four basic aids to this end: knowledge of other works of the period and of the artist, documentation and provenance; and a technical analysis of the materials in question. Very often specialist scholars have in the end to rely on their personal judgement. But scholars, being human, do not always agree with each other. It is therefore of the utmost importance for a collector to choose and judge his advisers with care. Norton Simon projected a healthy cynicism into his collecting activities, acquired not only from the many questions raised by the Duveen experience, but also from years of immersion in the world of commerce. He knew when to say yes and what to pass by. Ultimately Norton Simon's museum is a testament to his overriding appreciation of the aesthetic qualities of the work of art under consideration, for that which is, above all, beautiful. The Duveen files also taught him periodically to discard the second best in order to seek better examples of a master's work.

He has loaned extensive parts of his collection to various museums across the United States. There have also been very important loans of individual paintings to major international exhibitions. Rembrandt's *Titus*, for example, in addition to innumerable exhibitions throughout the world was one of only twenty-three paintings picked by Dutch scholars to be displayed at the Rijksmuseum in celebration of the 300th anniversary of the artist's death; the large Chardin *Dog and Game*, one of the few existing monumental Chardin paintings, recently travelled to Paris, Boston and Cleveland for the Chardin retrospective; the Daumier *Mountebanks Resting* has a long list of international exhibitions to its credit, as do the Renoir *Le Pont des Arts, Paris*, the Zurbaran *Still Life: Lemons, Oranges, and a Rose*, and many other renowned paintings.

In 1975, after the Pasadena Art Museum got into financial difficulties, Norton Simon took over responsibility for it. There had been some criticism of the Museum's new building, which was designed by Ladd and Kelsey and which had opened a few years earlier. But with minimal and sympathetic adaptation and some remodelling the Museum is now something of a *tour de force*, perhaps a little reminiscent of Henry van de Velde's Kröller-Müller Museum at Otterlo in Holland.

* * *

In a chronological sense, the European collection starts with a section of early Italian paintings ranging from the fourteenth to the sixteenth centuries. Two early examples are the magnificent altarpiece by Guariento di Arpo of 1344, which in its twenty-four panels displays a graphic summary of the highlights of the New Testament; and Giovanni di Paolo's *Branchini Madonna* with its serene composure, which was considered by the city of Siena to be the most beautiful work by the artist. Because of this they made a major attempt to retain the picture before it was bought by Baron Robert von Hirsch. Bellini's penetrating portrait of *Joerg Fugger* of 1474 and Lorenzo Monaco's gentle *The Virgin Annunciate* of about 1415 are outstanding examples of Venetian and Florentine fifteenth-century art. The sixteenth century is highlighted by the young Raphael's *Madonna and Child with Book* and Jacopo Bassano's stunning *The Flight into Egypt*. The group of Flemish tapestries, still splendid in the freshness of their colours, provides a rich insight into the taste for narrative wall hangings in the Low Countries during the fifteenth and sixteenth centuries.

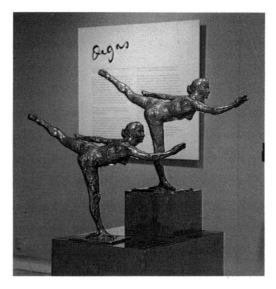

Hilaire-Germain-Edgar Degas 1834–1917
Arabesque Over the Right Leg, Left Arm in Line
Mid 1880s Bronze, *modèle* and a serialized
cast

The unique set of Romanelli cartoons, which exemplify the warm exuberance of the Baroque, gently usher the visitor towards the Flemish seventeenth century and the work of Sir Peter Paul Rubens, the greatest Flemish master of the Baroque, and that of Zurbaran, Murillo and El Greco from Spain. Zurbaran's only signed and dated still life, *Lemons, Oranges, and a Rose*, is generally recognized as one of the supreme achievements of its time.

Here, too, is a memorable selection from the masters of Holland: their portraits, interiors, landscapes, still lifes and exquisite flower pieces, culminating in Rembrandt's introspective self-portrait, the enchanting portrait of his son, *Titus*, and the no less incisive portrait of a man in a wide-brimmed hat. The French are also well represented: with two landscapes by Claude Lorrain and his incomparable sequence of sixty landscape drawings; with portraits by Largillière and Rigaud; still lifes by Louise Moillon; and Poussin's dramatic rendering of the story of *Camillus and the Schoolmaster of Falerii*.

Highlighting the eighteenth century in Italy is the immense Tiepolo ceiling depicting *The Triumph of Virtue and Nobility over Ignorance*, and Magnasco's mysterious *Interior with Monks*, which provides a sombre but memorable counterpoint to Tiepolo's ebullient colours. There is simple visual enjoyment in the examples of the *vedutists'* work by Carlevarijs, Guardi and Canaletto.

From eighteenth-century France there are light-hearted pictures by Boucher and Fragonard, and one of the gems of the collection, a tiny recumbent nude by Watteau, a charming composition dating from about 1715. Take care also not to miss the stunning portrait of the beautiful and pathetic *Theresa, Countess Kinsky* by one of the great female artists of the period, Marie-Louise-Elisabeth Vigée-Lebrun.

One cannot help but regard the nineteenth-century pictures as being two quite separate entities: those by the Impressionists and their followers and those by the more traditional painters who preceded them. The Norton Simon collection is strong in both respects. There are a number of fine Courbets and Corots and representations of Daumier, Delacroix, Boudin and many others from the pre-Impressionists. When we get to the work of Pissarro, Renoir, Manet, Monet, Cézanne, van Gogh, Toulouse-Lautrec, Gauguin, Vuillard, the Douanier Rousseau and their many contemporaries, the mind reels in astonishment. It is almost invidious to select examples, but Renoir's *Le Pont des Arts, Paris*, Monet's *Mouth of the Seine at Honfleur*, Cézanne's *Tulips in a Vase* and *Farmhouse and Chestnut Trees at Jas-de-Bouffan*, and van Gogh's portraits of his mother and of a peasant are supreme achievements of their kind.

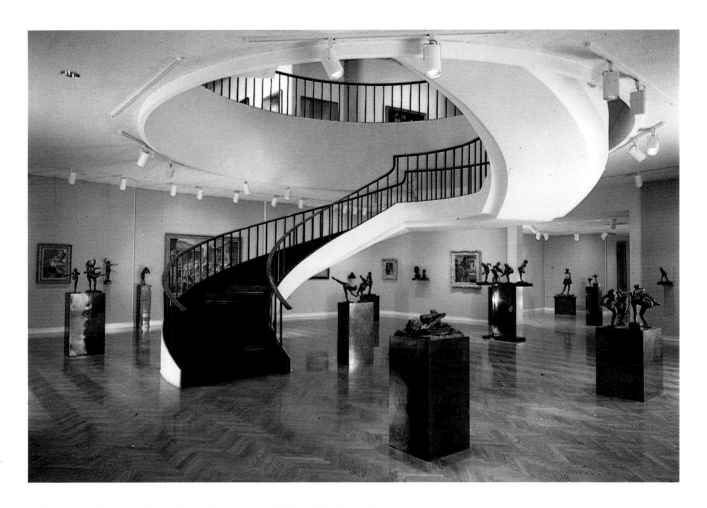

View of one of the Degas galleries

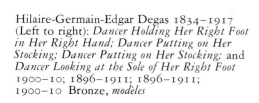

Hilaire-Germain-Edgar Degas 1834–1917
Horse Clearing an Obstacle and *Horse
Galloping on Right Foot*
1881–90 Bronze, *modèles*

Hilaire-Germain-Edgar Degas 1834–1917
(Left to right): *Dancer Holding Her Right Foot
in Her Right Hand; Dancer Putting on Her
Stocking; Dancer Putting on Her Stocking;* and
Dancer Looking at the Sole of Her Right Foot
1900–10; 1896–1911; 1896–1911;
1900–10 Bronze, *modèles*

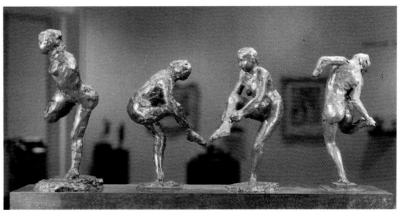

7

If Edgar Degas has not been mentioned yet it is because a feature of the Simon collection is not only the breadth of what it contains but also that the work of a number of major artists is represented in an unusually comprehensive way. As one descends the spiral staircase to the lower level of the Museum, for example, one sees revealed over one hundred examples of Degas' paintings, pastels and sculptures. The whole *ensemble* captures magnificently the Frenchman's genius for portraying arrested movement, whether it be two-dimensionally in the expression of fatigue by the two women ironing, the intimacy of *After the Bath* and in the tension of *Dancers in the Wings*, or three-dimensionally in the agony of the woman who is being massaged as she clasps her thigh, the many female dancers and the prancing horses. It is strange to think that only one piece of sculpture ever publicly saw the light of day in Degas' lifetime. The examples you see here of his tactile skill were cast in bronze from wax models found in his studio after his death. These unique casts are known as *modèles*, and as far as is known are the only original Degas bronzes.

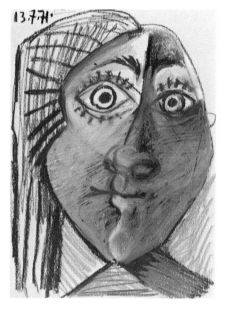

Pablo Ruiz y Picasso, 1881–1973 *The Moulin Rouge (Three Figures)* 1901 Ink drawing on paper 32.4 × 49.5cm

Pablo Ruiz y Picasso, 1881–1973 *Head of a Woman* July 13, 1971 Pastel on grey board 29.4 × 21cm

Indeed, if it is sculpture you enjoy, look around further. There is a wide range of the work of Maillol, Rodin, Lehmbruck, and many examples of our own great contemporaries—Giacometti, Henry Moore, Barbara Hepworth, Lipchitz, Brancusi, and a major David Smith. And if by now you need a moment of relaxation, wander outside into the beautiful setting of the sculpture garden, sit in the shade of the trees and admire the play of the fountains. When you re-enter the Museum the work of many of the great artists and their 'movements' of the twentieth century are there for you to see: Matisse, Rouault, Modigliani, Munch, Braque, Soutine, Kandinsky, Feininger, Paul Klee and Jawlensky—the last four strongly represented, thanks to the Galka Scheyer Bequest. Pablo Picasso, the outstanding figure of this century, is represented in amazing variety. You will find—at the times when it is on display—the whole gamut of his work from a pen-and-ink sketch done when he was a youth of twenty to one completed when he was an old man of ninety. Of the major paintings there are superlative

examples of his work ranging from 1906 until the 1950s. The 1932 *Woman with Book*, for example, is one of the major masterpieces in all of his *oeuvre*. His graphic works include many of his progressive suites and *bon à tirers*—lithographs, linocuts and etchings. This group constitutes an unusual statement about Picasso's working methods, and a major portion of its contents are never seen in other museum collections.

You should not be surprised to find change in what is displayed between one visit and another. There is, firstly, a frequent moving of pictures and sculpture in an unceasing endeavour to find improved juxtapositions; secondly, there are far more objects available than can ever be displayed at any given moment; and thirdly, despite the riches already there, the pace of acquisition has hardly slackened. Unique opportunities occur as other collections are dispersed; not only by purchasing single works, but sometimes by acquiring such collections in their entirety. A case in point: the Museum contains a major portion of the etchings by Rembrandt van Rijn—all the landscapes, many of the portraits and figure studies, as well as biblical and other scenes. The collection began with the purchase of a corpus brought together by one of America's important contemporary private collectors of Rembrandt etchings, and that acquisition has continued to inspire purchases.

In a similar vein, the collection of etchings and lithographs of Francisco Goya is enormously extensive. The Museum has the entire sequences of the *Caprichos*,

Jean-Honoré Fragonard, 1732–1806 Study after Nicolas Poussin *The Rest on the Flight Into Egypt*
1760–61 Black chalk drawing
31.6 × 23.5cm

Jean-Honoré Fragonard, 1732–1806 Study after G. B. Tiepolo *Immaculate Conception*
1760–61 Black chalk drawing 21.0 × 28.6cm

9

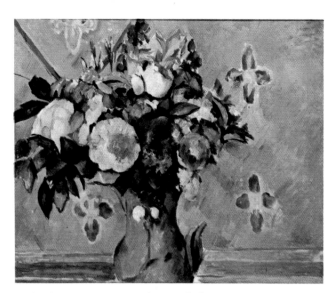
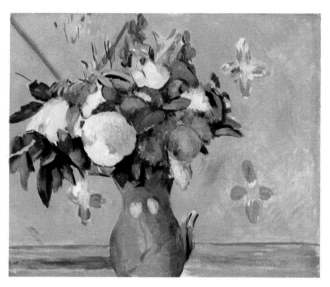

Paul Cézanne, 1839–1906 *Vase of Flowers*
c. 1879–82 Oil on canvas 47 × 55.2cm

Odilon Redon, 1840–1916 *Vase of Flowers* (copy after Cézanne)
1896 Oil on canvas 46.4 × 55.2cm

The Disasters of War, *Los Disparates*, *La Tauromaquia* and the *Bulls of Bordeaux*. Not only are there first edition sets of them all, but also rare trial and working proofs of these series, as well as other unusual Goya graphics, which give a clear idea of what the artist was intending to achieve.

Occasionally the Museum also displays some or all of the 139 delicate pencil sketches by Jean-Honoré Fragonard. These drawings represent his interpretation of the masterpieces by older painters which were to be seen in the major Italian cities in 1760. They reveal Fragonard's native talent before it developed into the style for which he is much better known.

Here and there, almost surreptitiously, the Museum will instruct you gently in the nuances of the history of art. Look, for example, at the two apparently very similar paintings of a vase of flowers by Paul Cézanne and Odilon Redon. The story behind them is that Cézanne's picture was bought in Paris by André Bonger, a Dutchman, and as it happened the brother-in-law of Theo van Gogh. He suddenly found that he had to go to London, so he left the canvas with Redon, with whom he had been staying. Redon was so intrigued by the mastery of Cézanne's technique that he produced a copy in his own style. Upon his return Bonger at first mistook it for Cézanne's own painting, although it did not take long for the genius of Cézanne's art to reveal itself.

If you want to see how a painter develops the swift strokes of a rough sketch of an initial idea into a finished, more formal picture, look at Daumier's *Mountebanks Resting*: both versions of his work are here. Daumier was one of the greatest caricaturists of his time, who in his maturity turned to painting. Clowns, actors and mountebanks are amongst those characters who intrigued him, and in this study he was obviously trying to probe to the personalities hidden behind the professional masks. Or see how a painter has to study the work of the earlier masters to perfect his feeling for the human figure and movement, and pause for a moment before Degas' copy of Poussin's *Rape of the Sabines*, which you might easily mistake for a work that has strayed into the wrong gallery: it seems so perfect a rendering of a theme beloved by artists of the seventeenth century. Degas' version of Poussin's picture encapsulates much that continued to fascinate him throughout his life: the representation of the pause between actions, the movements of a graceful horse, and the classical draftsmanship which was to remain the backbone of his art.

The fact that one man and one mind are behind the acquisition of what you see displayed leads to remarkable parallels: for example, Jan van der Heyden's

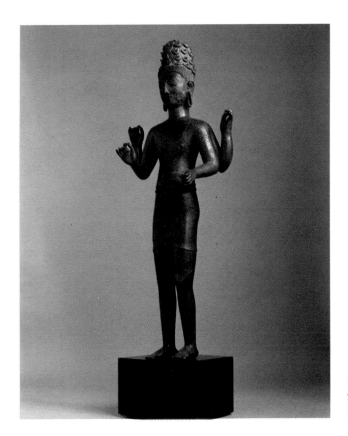

Cambodian; *The Bodhisattva
Avalokiteshvara* Pre-Angkor
Period 8th century
Bronze 91.4cm high

Library Interior with Still Life and Charles Duvivier's *An Architect's Table*. The
first was painted by a Dutchman in 1711 and the second by a Frenchman in 1772.
But probably the most striking instance of this constancy of vision is in the many
versions of the sculptured realization of the female form by Degas, Maillol,
Rodin and their contemporaries.

One entire section of the Museum is devoted to the sculpture of India,
Pakistan, Cambodia and Thailand, images of a different culture, most of them
much older than the examples of Western art so far discussed. Eight years ago
Norton Simon visited India for the first time, in the company of his wife,
Jennifer Jones, who had long had an interest in Eastern philosophy and the art of
India. His first purchase was the elaborately carved eighteenth-century chess set
you will see as you approach the gallery of Asian art. But his eyes were opened to
the serenity and majesty of early Buddhist and Hindu sculpture generally.
Indian art is as complex as the theology that generated it. As you will see here, it
reached several peaks of perfection, such as the Gandaran period from the
second to the fifth century, which manifests strong Hellenistic influences; the
Gupta dynasty between the fourth and the sixth century A.D.; and the Chola
dynasty of the tenth to the twelfth century. A pair of the most exquisitely
modelled pieces of Chola sculpture are the Shiva and Parvati from South India.
They are among the numerous Chola bronzes in the Museum, which now houses
what is probably the richest and one of the most varied Indian and South-East
Asian sculpture collections outside India. The impressive art of ancient Cam-
bodia, more finely meditative in its portraiture than much of Indian sculpture, is
also extensively represented.

* * *

Visitors frequently ask how it is that so much of genuine quality can have been
assembled in such a relatively short space of time. Norton Simon has built up,

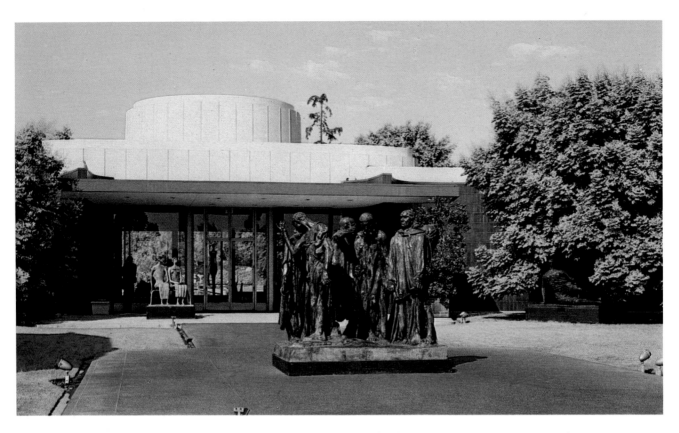

The approach to the Norton Simon Museum, with Rodin's *Burghers of Calais* and Henry Moore's *King and Queen* and *Draped Reclining Figure*

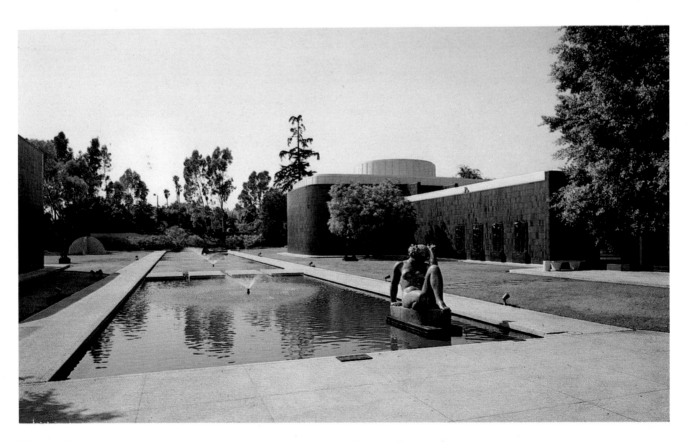

View of the sculpture garden, including Maillol's *Mountain* and Matisse's four *Backs*

with the aid of a devoted staff, an astonishing network of communications with dealers and sale rooms all over the world. He has bought widely at Sotheby's and Christie's in London, at Parke Bernet in New York, and at other auction galleries in Paris, Germany and Switzerland. He prefers bidding over the telephone: it gives him a helpful sense of detachment.

For those involved with the purchasing, almost every acquisition has a fascinating background story. This applies particularly in the case of some of the major works bought at auction. Take, for example, the previously almost forgotten, magnificent Bassano of *The Flight into Egypt*. It was bequeathed in 1958 by an English architect to the monks of Prinknash Abbey in Gloucestershire, with the understanding that it could be sold if ever the religious community was in need. At that time the painting was insured for £2,500. Such a need occurred when the monks found themselves unable to complete the erection of a partly constructed new building. The picture was consigned for sale at Christie's, together with seven others, in the hope that between them they would raise some £40,000. In the event the Bassano alone was bought against fierce competition by Mr Simon for £273,000. The monks were delighted: they were able not only to complete the building in question but almost their entire monastery.

Probably the most publicized purchase at auction was the occasion in 1965 when Mr Simon bought the enchanting portrait by Rembrandt of his son, *Titus*, that had been in the collection of the Earls of Spencer at Althorp, and then of Sir Herbert Cook at Doughty House, Richmond, Surrey. Mr Simon had arranged an elaborate system of bidding with Christie's, depending on whether he was standing up or sitting down. In the excitement of the moment a misunderstanding occurred and the picture was knocked down to another bidder at £777,000. When it became clear that the matter was in dispute the auctioneer reopened the bidding and Mr Simon carried the day at £798,000—for a long time a record for any painting sold at auction in Britain.

The collection has continued to grow, and the results you will see around you at Pasadena today. The Museum itself is young. As public awareness of it increases, appreciation of its contents will grow. There are many individual paintings that have already captured the public imagination. This is the first book on the collection that indicates the breadth of its contents, and it is hoped to follow it up with additional publications for both the scholar and art-lover.

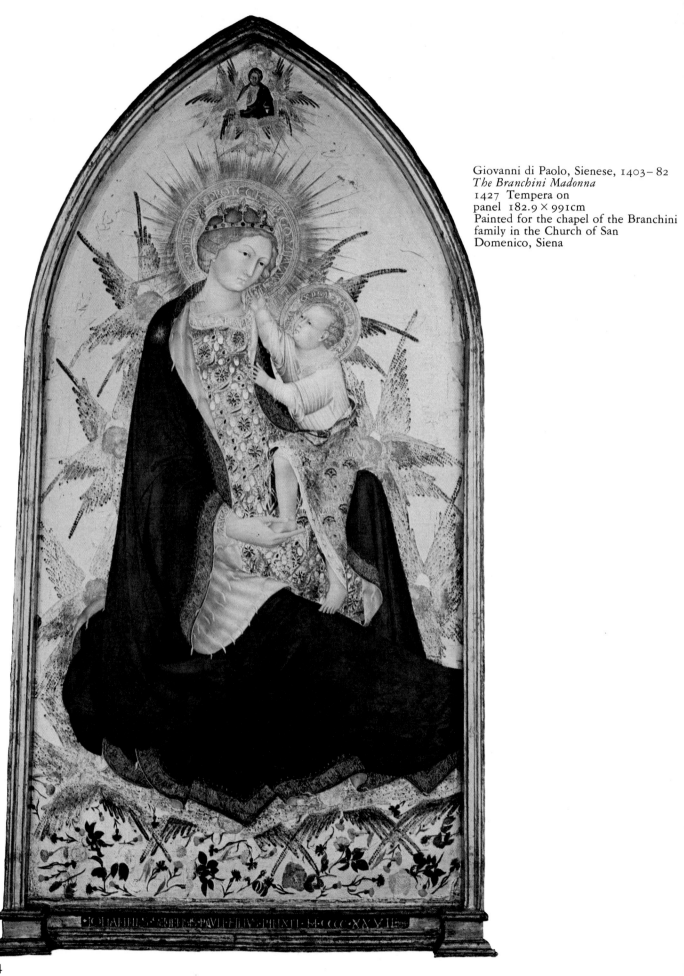

Giovanni di Paolo, Sienese, 1403–82
The Branchini Madonna
1427 Tempera on
panel 182.9 × 99 1cm
Painted for the chapel of the Branchini
family in the Church of San
Domenico, Siena

Pre-Renaissance and Renaissance

The artist's skill in the later Middle Ages was tightly harnessed to the service of the Church. The outlets for his work were altarpieces, wall-paintings (frescos), decorative panels for furniture (usually for large chests known as *cassone*) and occasionally shrines for the wealthier homes. Italy harboured a high proportion of the talent of the time and artists tended to follow styles characteristic of the major urban centres such as Florence, Siena, Venice, Milan and Padua. The inspiration for their work came from a detailed knowledge of the Bible and from the lives of saints and martyrs, the most venerated servants of the Church. Sculptors and weavers took over where the painters left off.

This collection is strong in examples of the Sienese masters. The earliest are the two altarpiece panels of Elisha and St. John the Baptist painted by Pietro Lorenzetti around 1330. The most striking of these works is Giovanni di Paolo's *Branchini Madonna* of 1427, painted as the central panel in an altarpiece for the chapel of the Branchini family in the church of San Domenico in Siena. You will see the same artist painting in his later style in *The Baptism of Christ* of the early 1450s.

In Florence, Pacino di Bonaguida's *Madonna and Child Enthroned* of the early fourteenth century strikes a rare balance between an almost iconic treatment of the Virgin and Child, an inheritance from the older Byzantine tradition, and a new sense of plasticity in the figure of St. Francis. Guariento di Arpo's immense multi-panelled altarpiece, *Coronation of the Virgin* of 1344, reveals the growing realism of figures forged under the influence of Giotto. A new stage in portraying the human form is reached in Filippino Lippi's two large altar panels of *SS. Benedict and Apollonia* and *SS. Paul and Frediano* of 1483, which were painted for San Ponziano in Lucca and described by Vasari in his life of the artist. The High Renaissance sought stability and monumentality in its organization of idealized figures, which we can see in the youthful Raphael's *Madonna and Child with Book*, where the mother and child are imbued with mellow tenderness.

Portraiture in its own right was not introduced in Italy until the latter part of the fifteenth century. One of the earliest paintings in oil in Renaissance Venice was Giovanni Bellini's *Portrait of Joerg Fugger*, a sensitive study of a scion of a German merchant family. Dated 1474, it has additional historical importance as it is one of the first works painted in oil by an Italian artist. Until then Italians had painted exclusively in tempera (an egg rather than an oil-based paint). The new technique had originated in Northern Europe early in the fifteenth century, yet in the sixteenth century the flow of artistic ideas was mainly from Italy to the north. Lucas Cranach the Elder's *Adam* and *Eve*, for example, show a German artist uniting the ideal figure of the Italian Renaissance, known through Dürer's engravings, with an older Northern tradition. Flemish painters as well were greatly influenced by Italian art, as can be seen in Jan Metsys' striking *Susanna and the Elders*, which at first sight might be mistaken for an Italian painting.

Jacopo Bassano's *The Flight into Egypt*, almost contemporary with Cranach's *Adam* and *Eve*, demonstrates a new impression of movement combined with a brilliantly colourful palette. At the same time it still reflects the Venetian High Renaissance in, for example, the pose of the Virgin, which is taken from a well-known fresco by Titian in Venice. The painting conveys an altogether fresh sense of vigour and robustness that must have startled the generation which first saw it.

Bernardo Daddi, Florentine, 1310–50 *Madonna and Child Enthroned with St. John Gualbertus, John the Baptist, and SS. Francis and Nicholas*
*c.*1330–36 Tempera on panel 36.2 × 21cm

Neroccio de'Landi, Sienese, 1447–1500 *Madonna and Child with Saints*
*c.*1480 Tempera on panel 69.9 × 58cm

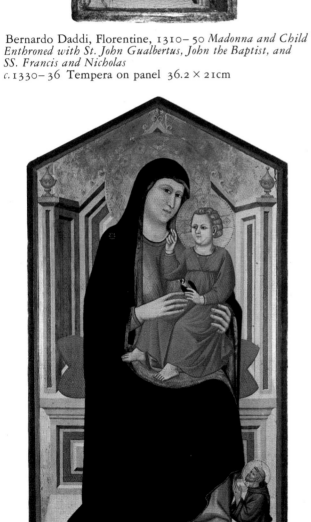

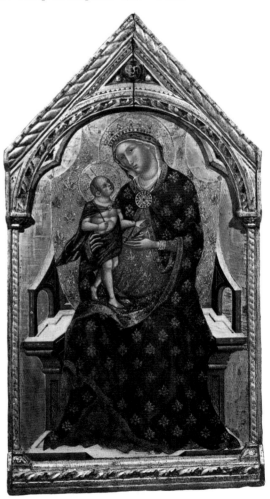

Pacino di Bonaguida, Florentine, *Madonna and Child Enthroned with St Francis*
14th century Tempera on panel 126.4 × 68.9cm

Paolo Veneziano, Venetian, active 1324–58; d. 1362
Madonna and Child
*c.*1340 Tempera on panel 110.7 × 61.9cm

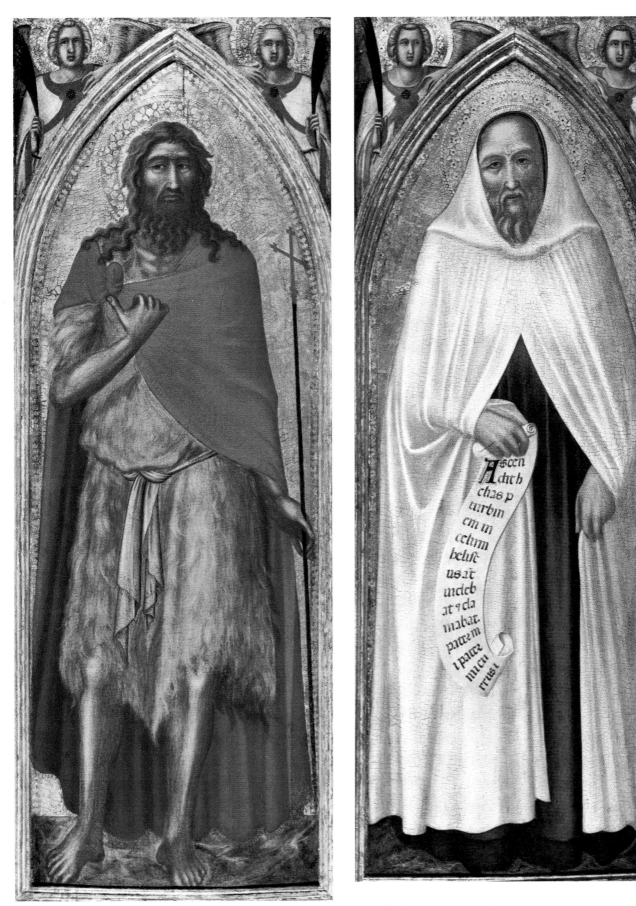

Pietro Lorenzetti, Sienese, *c*. 1280–1348? *St. John the Baptist* and *Elisha* Tempera on panel 124.5 × 45.7cm each
From the altarpiece with Saint Agnes and Catherine of Alexandria in Siena, now in the Pinacoteca in Spain.

Guariento di Arpo, Paduan, *c.*1310–70 *Coronation of the Virgin Polyptych* 1344 Tempera on panel 215 × 260.9cm overall

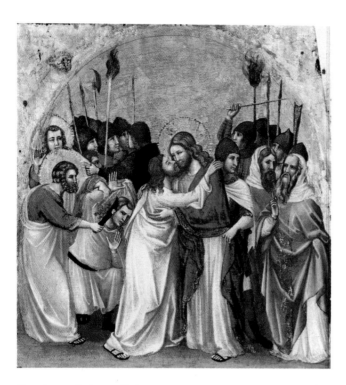

Guariento di Arpo, Paduan, *c.*1310–70
Coronation of the Virgin Polyptych (detail)
The Betrayal of Christ
1344 Tempera on panel 42.5 × 39.6cm

Venetian School *Scenes in the Life of Christ with Patron Saints* (15 scenes)
*c.*1300 Tempera on panel 41.5 × 66.9cm

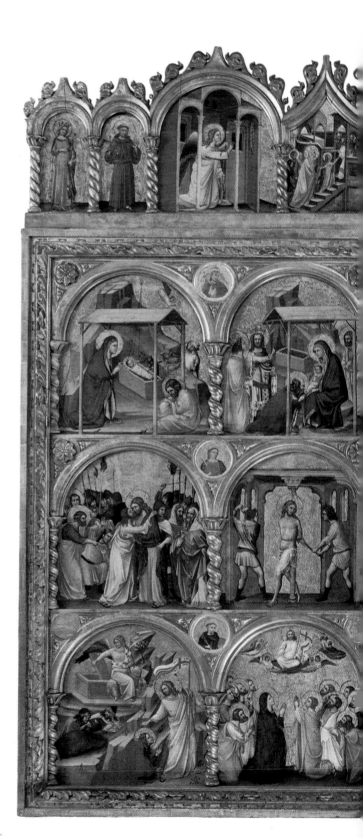

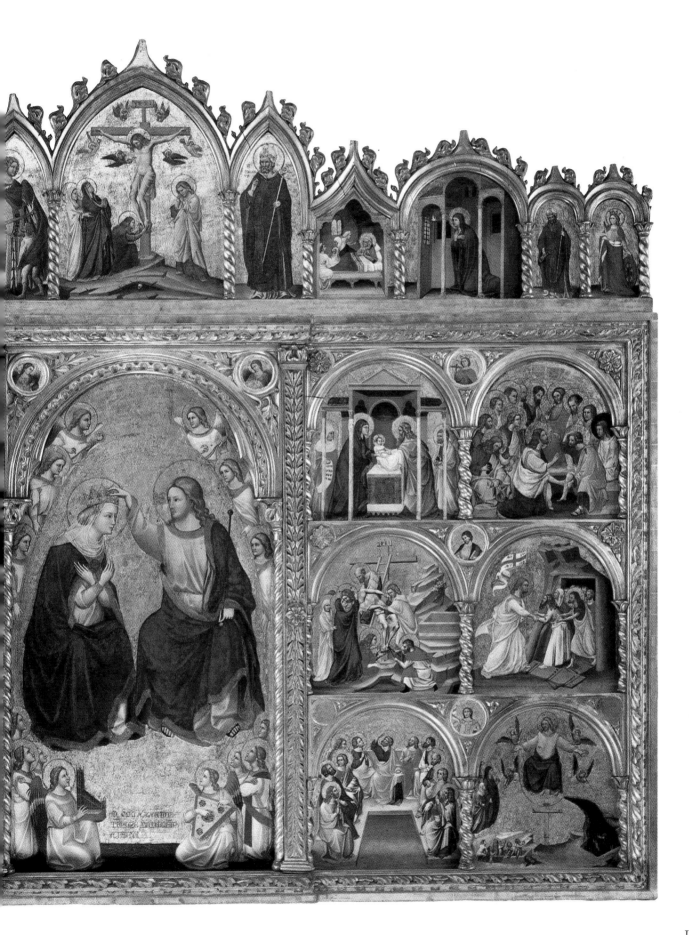

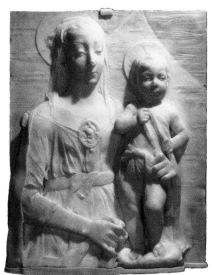

Desiderio da Settignano, Florentine,
1428–64 *The Beauregard Madonna
(Madonna and Child)*
c. 1455 Carrara marble
50.8 × 40.6cm

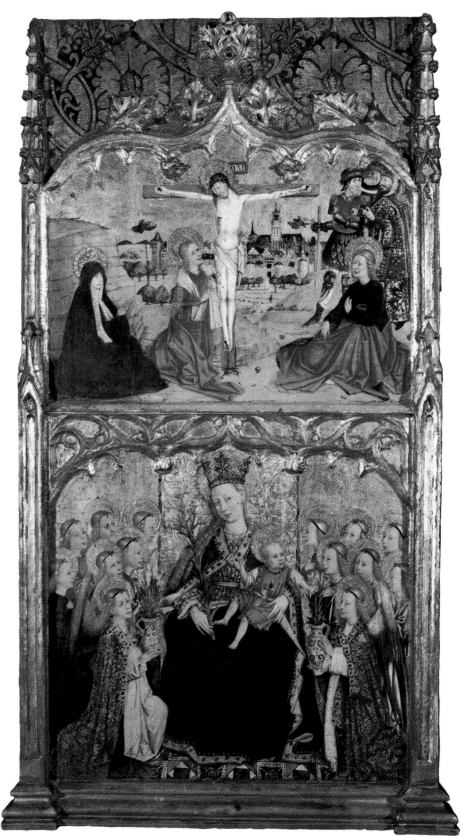

Juan Rexach, Spanish, active 1443–84 *The Crucifixion* and *Madonna and Child
Enthroned*
Late 1460s Tempera on panel 174 × 97.8cm

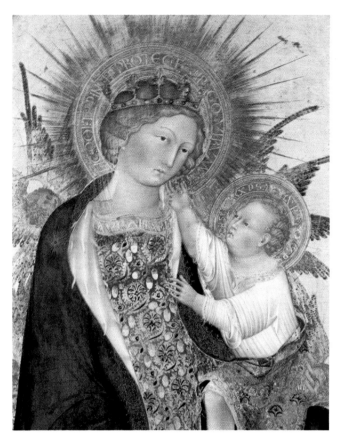

Giovanni di Paolo, Sienese, 1402–82 *The Branchini
Madonna* (detail) 1427 Tempera on panel

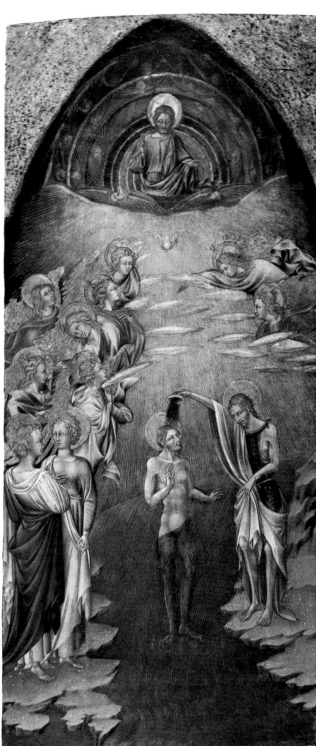

Giovanni di Paolo, Sienese, 1403–82 *The Baptism of Christ*
*c.*early 1450s Tempera on panel 75.8 × 33.2cm

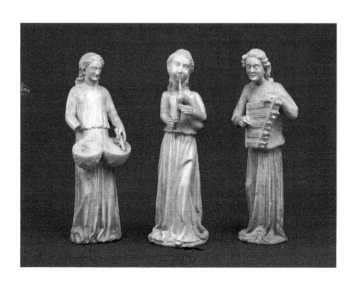

Florentine School *Three Angel Musicians Playing Zither,
Bagpipe, and Timbrels*
*c.*1350–1400 Marble 50.8 × 13cm; 50.8 × 16.5cm;
50.2 × 14cm

Lorenzo Monaco, Florentine, *c.* 1370–1425 *The Virgin Annunciate c.* 1410–15 Tempera on panel 80.2 × 44.5cm

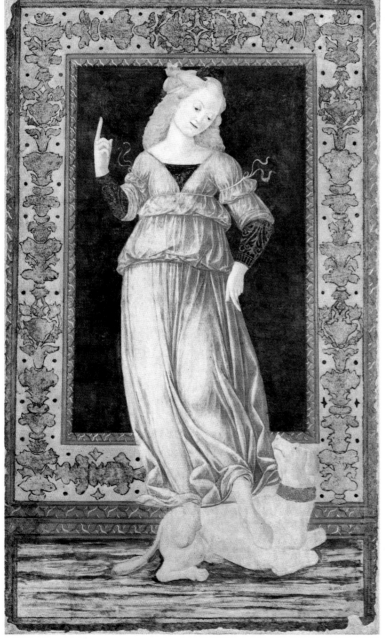

Francesco di Giorgio, Sienese, 1439–1502 *Fidelity*
Fresco transferred to canvas mounted to cradled wood
panel 125.7 × 75.6cm

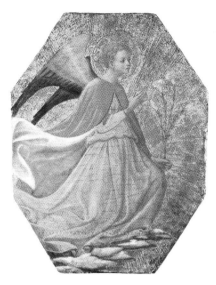

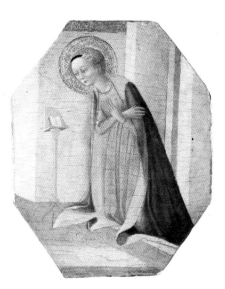

Florentine School
The Virgin Annunciate
15th century Tempera on
panel 32.4 × 25.4cm

Florentine School, *The Archangel
Gabriel*
15th century Tempera on
panel 32.4 × 24.8cm

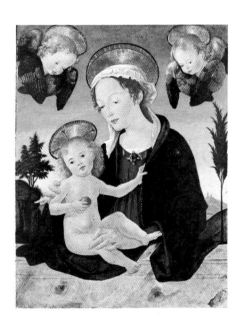

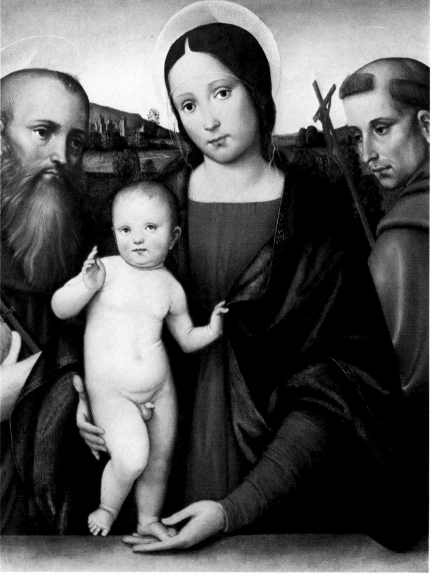

Antoniazzo Romano, Italian,
1460–1508 *Madonna and Child with
Two Cherubim*
Tempera on panel 53.3 × 41.9cm

Francesco Francia, Bolognese, *c.*1450–1517/18 *Madonna and Child with
SS. Jerome and Francis*
Oil on panel 62.9 × 47.2cm

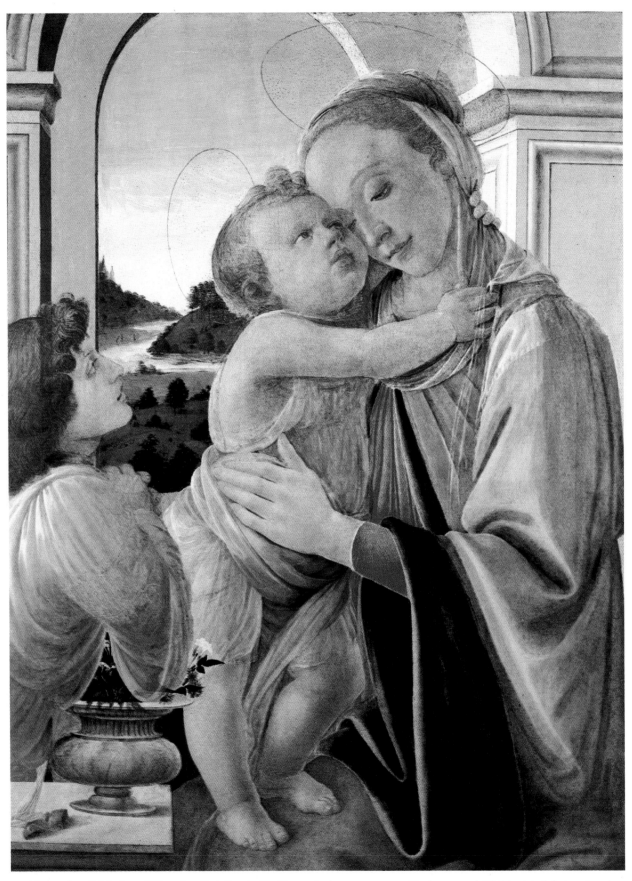

Alessandro di Mariano Filipepi, called Botticelli, Florentine, *c*.1444–1510 *Madonna and Child with Adoring Angel*
Tempera on panel 87.6 × 64.1cm

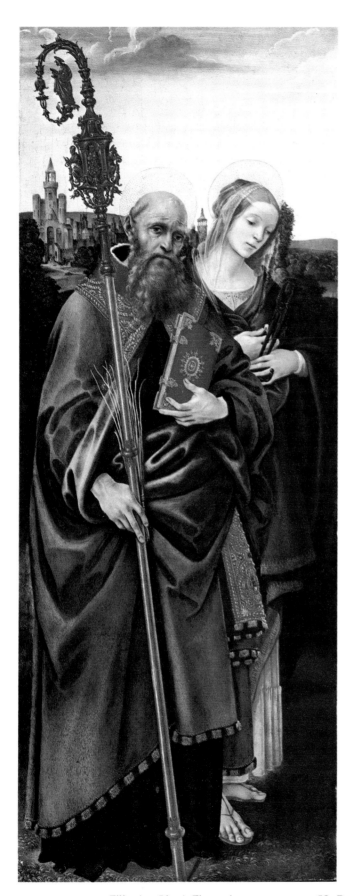

Filippino Lippi, Florentine, 1457–1502 *SS. Benedict and Apollonia* and *SS. Paul and Frediano*
*c.*1483 Tempera glazed with oil on panels 156.2 × 59.1cm (SS. Benedict & Apollonia),
156.2 × 58.7cm (SS. Paul & Frediano) Painted for the Church of San Ponziano, Lucca

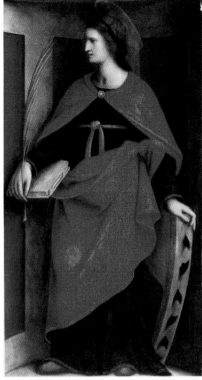

Bernardino Luini,
Lugano,
*c.*1481/2–1532 *Seven panels from the Torriani Altarpiece*
1525
Painted for the
Torriani Chapel,
Church of St.
Sisinnius La Torre,
Mendrisio, Lugano

St. Alexander Oil on
panel, cradled
62.5 × 34.3cm

*St. Catherine of
Alexandria* Oil on
panel, cradled
62.5 × 34.3cm

The Story of the Val di Non:
The Ordination Oil on poplar
wood 32 × 27.9cm

The Altar of Saturn Oil on poplar
wood 32.4 × 47cm

The Martyrdom of Sisinnius Oil on poplar
wood 31.8 × 46.4cm

*The Martyrdom of Martyrius and
Alexander* Oil on poplar
wood 31.8 × 28.6cm

Vow of the Three Friends Oil on poplar wood
32 × 41.9cm

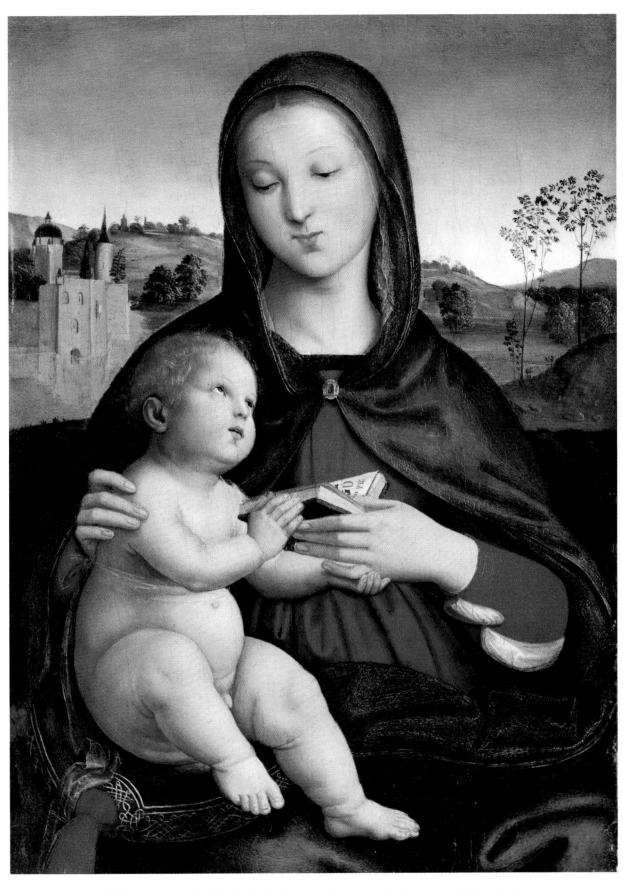

Raffaello Sanzio, called Raphael, Umbrian, 1483–1520 *Madonna and Child with Book*
c. 1504 Oil on panel 55.2 × 40cm

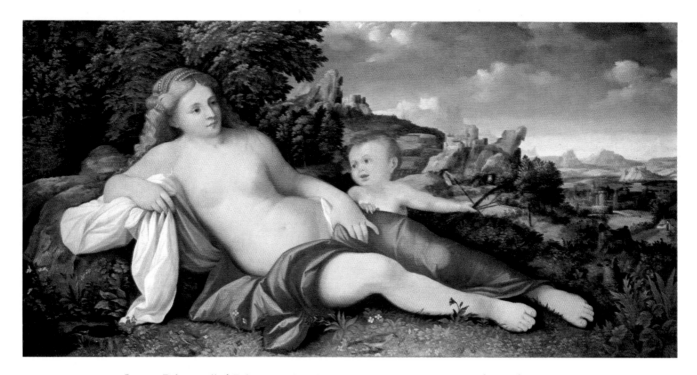

Jacopo Palma, called Palma Vecchio, Venetian, 1480–1528 *Venus and Cupid in a
Landscape*
Oil on canvas 88.3 × 167.2cm

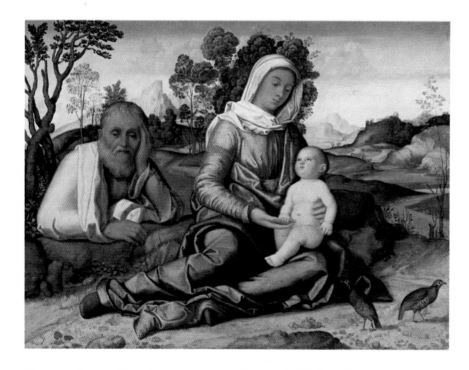

Vincenzo Catena, Venetian, *c.*1470–1531 *Rest on the Flight to Egypt*
Oil on panel 81.3 × 109.2cm

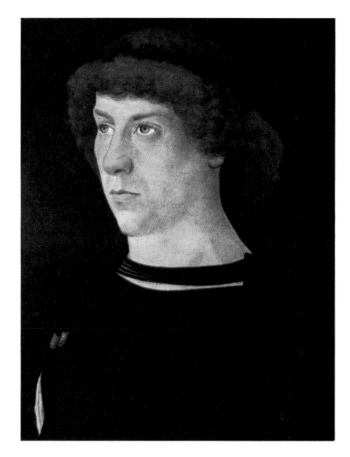

Giovanni Bellini, Venetian, 1430–1516 *Portrait of Joerg
Fugger* 1474 Oil on panel 26 × 19.9cm

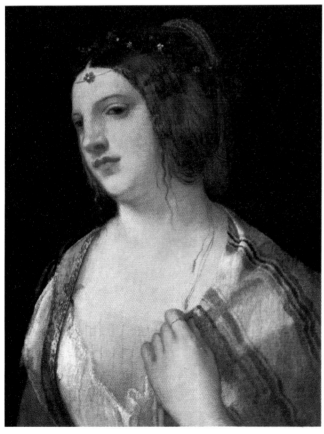

Giorgio da Castelfranco, called Giorgione, Venetian,
*c.*1477–1510 *Bust Portrait of a Courtesan*
*c.*1509 Oil on panel 31.1 × 23.8cm

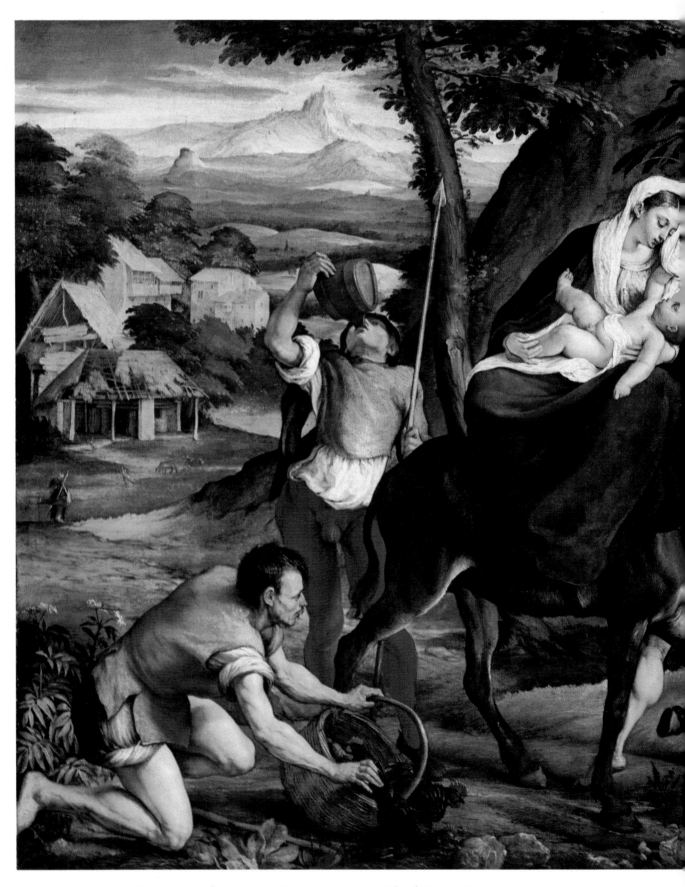

Jacopo da Ponte, called Il Bassano, Venetian, 1510–92 *The Flight into Egypt*
*c.*1540 Oil on canvas 119.4 × 198.1cm

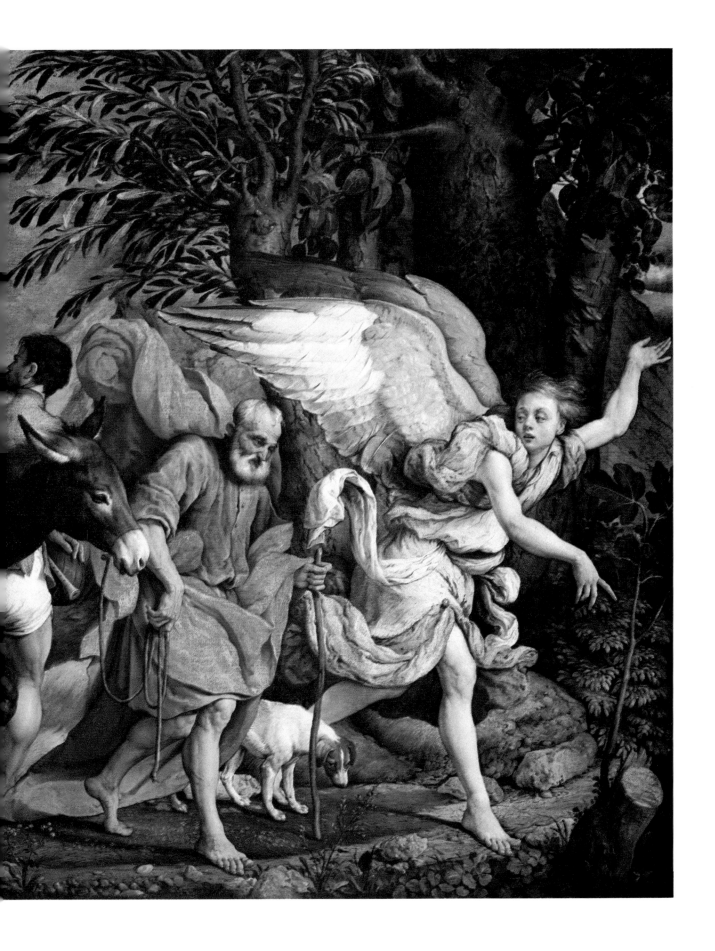

Giovanni Battista Moroni, Bergamo, 1510/25–78 *Portrait of an Old Man*
Oil on canvas 50.8 × 41.9cm

Domenikos Theotocopoulos, called El Greco, Spanish, 1541–1614 *Portrait of an Old Man with Fur*
*c.*1590/1600 Oil on canvas 47 × 38.7cm

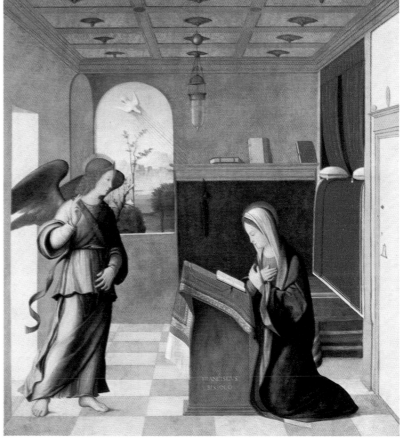

Vittore Carpaccio, Venetian, 1455–1526
Portrait of a Venetian Nobleman
*c.*1510 Oil on panel 35.6 × 27.3cm

Francesco Bissolo, Venetian, active 1492,
d. 1554 *The Annunciation*
Oil on panel 111.1 × 100.3cm

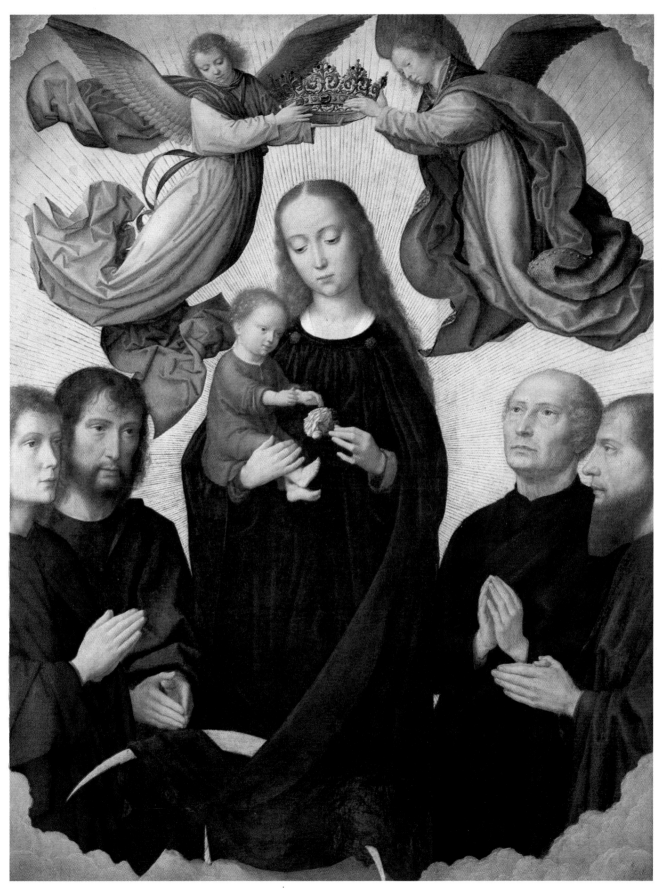

Gerard David, Netherlandish, 1450/60–1523 *Coronation of the Virgin*
Oil on panel 70.7 × 54cm

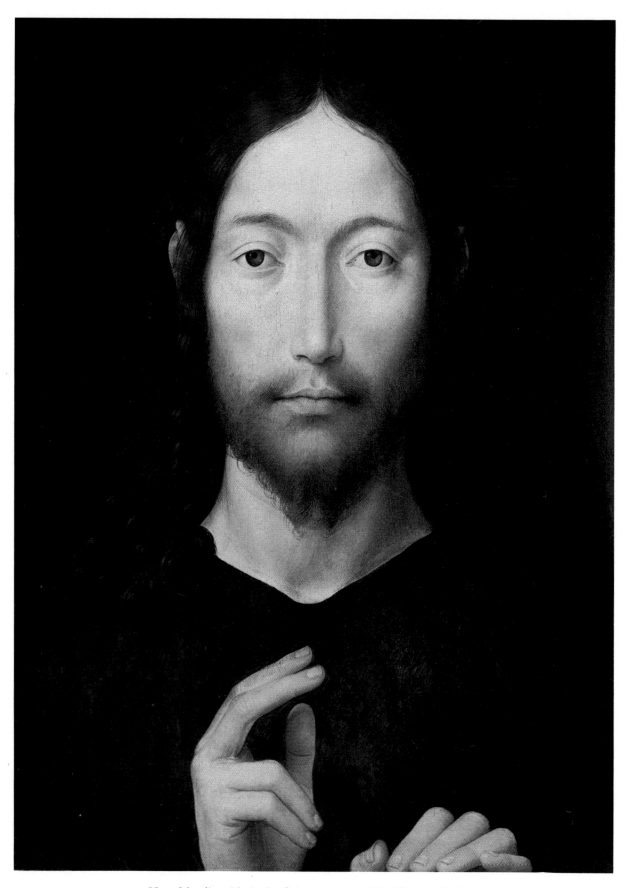

Hans Memling, Netherlandish, *c.* 1430– 94 *The Blessing Christ*
1478 Oil on panel 38.4 × 28.6cm

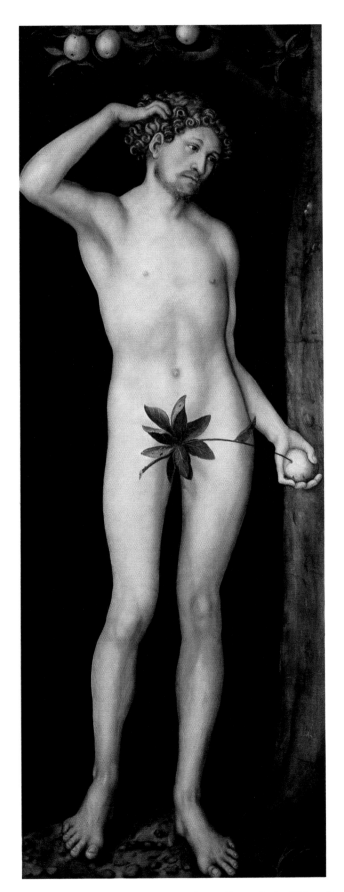
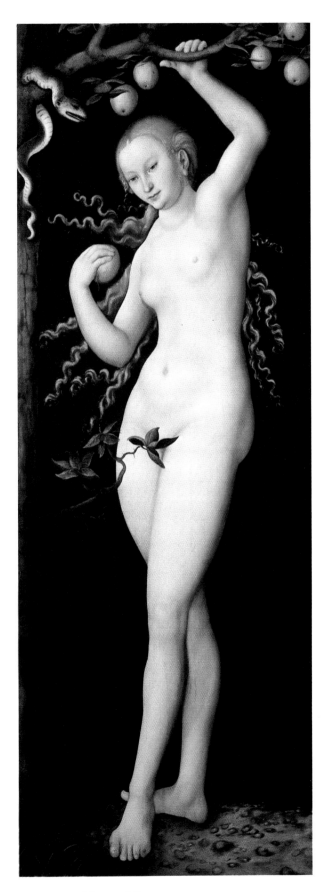

Lucas Cranach the Elder, German, 1472–1553 *Adam* and *Eve*
*c.*1530 Oil on panel 190.5 × 69.9cm each

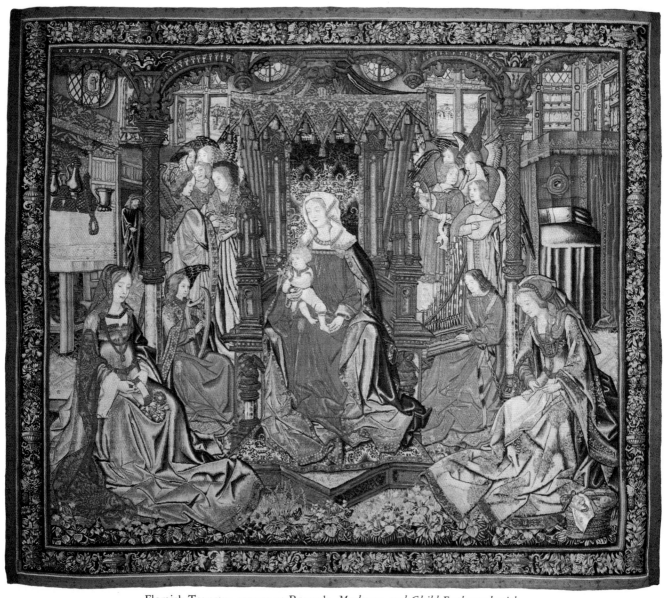

Flemish Tapestry, woven at Brussels, *Madonna and Child Enthroned with Mary Cleopathas and Mary Salome and a Concert of Angels*
*c.*1515 Woven wool, silk, and gold thread 259.1 × 294.6cm

Marten van Heemskerk, Netherlandish, 1498–1574 *Natura*
1567 Oil on panel 36.8 × 158.8cm

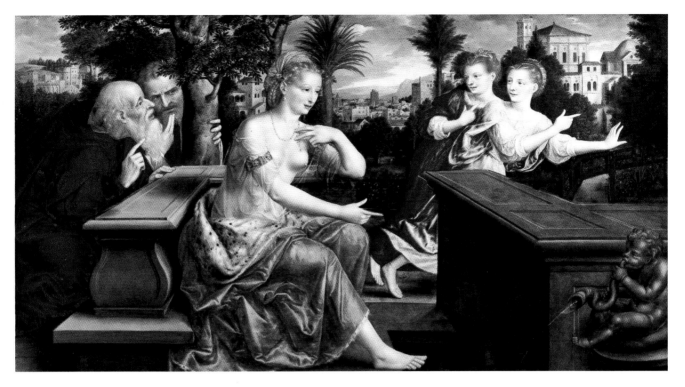

Jan Metsys, Netherlandish, active 1531, d. by 1575 *Susanna and the Elders*
1564 Oil on panel 104.8 × 193.9cm

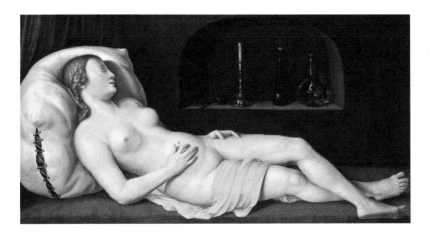

Georg Pencz, German, *c.*1500– 50 *A Sleeping Woman (Vanitas)*
1544 Oil on canvas 94 × 177.1cm

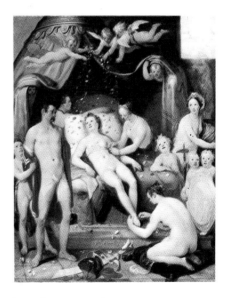

Cornelis van Haarlem, Netherlandish,
1562–1638 *Marriage of Mars and Venus*
1599 Oil on copper 55.2 × 43.8cm

37

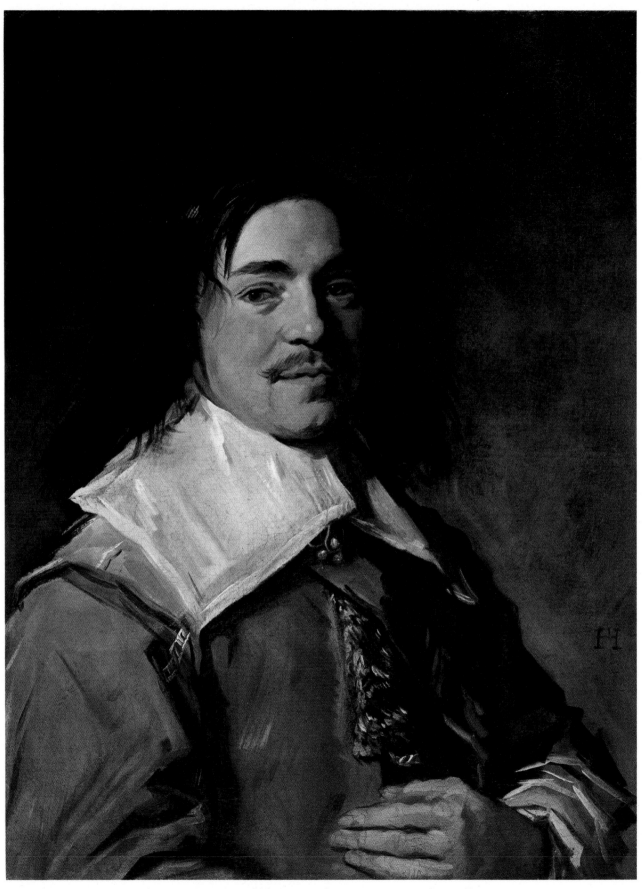

Frans Hals, 1580–1666 *Portrait of a Painter (Jan van de Capelle?)*
1650–5 Oil on canvas 66 × 49.5cm

The Seventeenth Century

At the beginning of the seventeenth century a wave of change in the arts began to sweep across Europe. Italy was the first country to be affected by a rising desire to involve the viewer more actively with the work of art. Lighting within a painting became more dramatic and compositions once again became clearer and more easily readable, as they had been in the Renaissance. Rome remained the artistic capital of Europe and most painters spent some time there during their careers, but strong national schools developed in France, Spain, the Netherlands and Holland. In Catholic countries the majority of paintings commissioned were still of religious subjects, and the Church remained the principal patron. Guido Reni painted his *Saint Cecilia*, with its dramatic spotlighting of the patron saint of music, for a cardinal of the Church; Rubens' *David Slaying Goliath*, with its active circular rhythmn, was a devotional painting; and Zurbaran's *The Birth of the Virgin* was one of eight scenes painted for a church in Seville.

Scenes from history and mythology were equally prized. For example, Poussin's *Camillus and the Schoolmaster of Falerii* portrays the virtue of a wise Roman general, while Romanelli illustrates the tragic love story of Dido, Queen of Carthage, and Aeneas, the Trojan hero on his way to found Rome in *The Royal Hunt and Storm*. Complete sets of tapestry cartoons such as these are extremely rare, and there appears to be no comparable series in the United States. They give the viewer some indication of the scale and grandeur of the century's major interior decorations.

How different in style and content are the majority of paintings produced in Holland! There was a remarkable flowering of talent in the new Dutch Republic: for the first time artists began to look at their own countryside and the teeming everyday life around them. The paintings of Salomon van Ruysdael and Aert van der Neer show artists capturing the flat landscape and its volatile, ever-changing sky. The robust life of the peasants is depicted in paintings by Jan Steen and the Ostades. Portraiture is brought to a new peak with the paintings of Hals and Verspronck and the radiant beauty of flowers glows in the paintings of Bosschaert and de Heem.

It is, however, Rembrandt who dominates Dutch painting. No other artist equalled his marvellous use of light and shade, his supreme ability to penetrate the characters of his sitters in portraits, and the simplicity and wondrous mastery of line in his drawings and etchings. His *Self-Portrait* of the late 1630s shows him at the pinnacle of his success: he was then the leading portrait painter in Amsterdam, married to the wealthy heiress Saskia, and the proud owner of a large house. The portrait of his son, *Titus*, painted over a decade later, looks out with a captivating directness, a haunting charm that enchants all who look at it.

A number of other seventeenth-century artists are well represented. Among them are Rubens, the genius of religious drama in Flanders, Claude Lorrain, the master of the idealized pastoral landscape, and Murillo, called in his day 'The Spanish Raphael'. The full range of the powers of the Spanish painter Zurbaran can be savoured in the four paintings in the Museum, from the religious intensity of *St. Francis in Prayer* to the quiet spirituality of *The Birth of the Virgin* and the dignity of his portrait of *Fray Diego Deza*. Through an unerring placement and subtle lighting, Zurbaran in his *Still Life: Lemons, Oranges, and a Rose* heightens the reality of an arrangement of simple objects. They become larger than life, taking on the proportions of the greatest art.

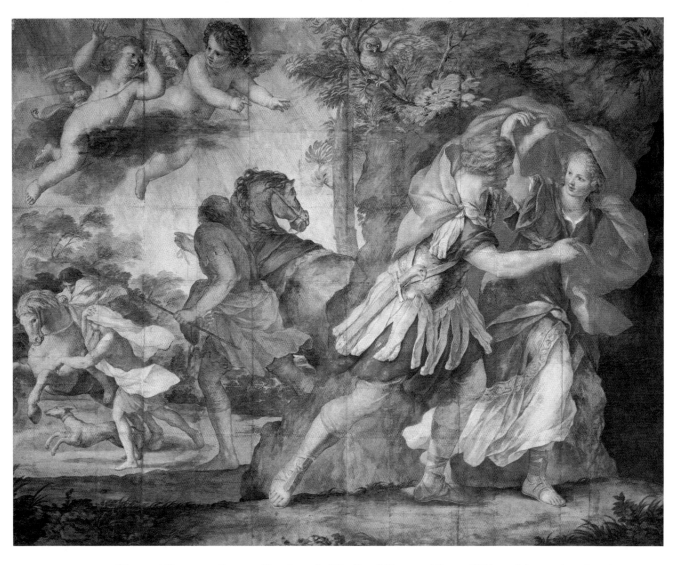

Giovanni Francesco Romanelli, 1610–62 *The Royal Hunt and Storm (Dido and Aeneas in a Storm)*
Gouache on paper laid down on linen 276.9 × 350.5cm

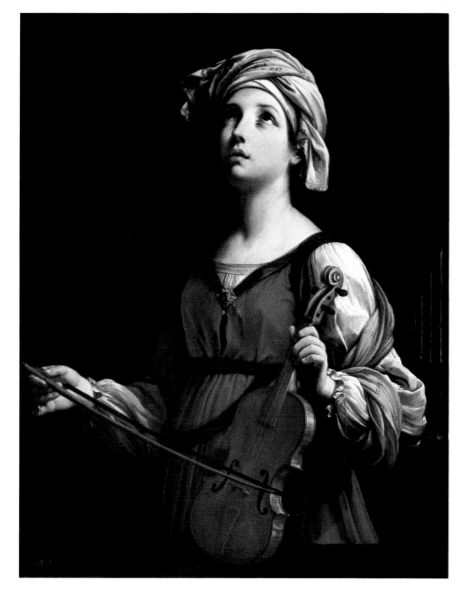

Guido Reni, 1575–1642 *Saint Cecilia*
1606 Oil on canvas 94.6 × 74.9cm

Giovanni Francesco Barbieri, called
Guercino, 1591–1666 *The Suicide of
Cleopatra*
*c.*1621 Oil on canvas 116.8 × 93.3cm

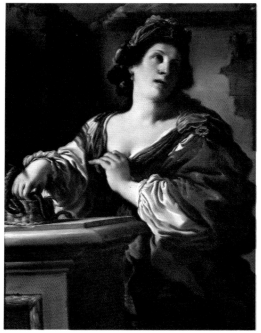

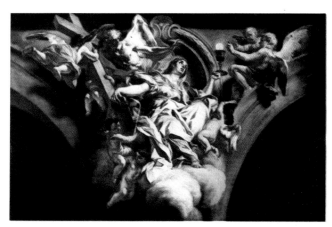

Francesco Solimena, 1657–1747
The Personification of Faith
Oil on canvas 49.5 × 76.2cm

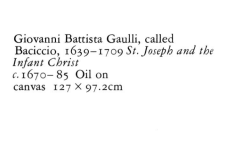

Giovanni Battista Gaulli, called
Baciccio, 1639–1709 *St. Joseph and the
Infant Christ*
*c.*1670–85 Oil on
canvas 127 × 97.2cm

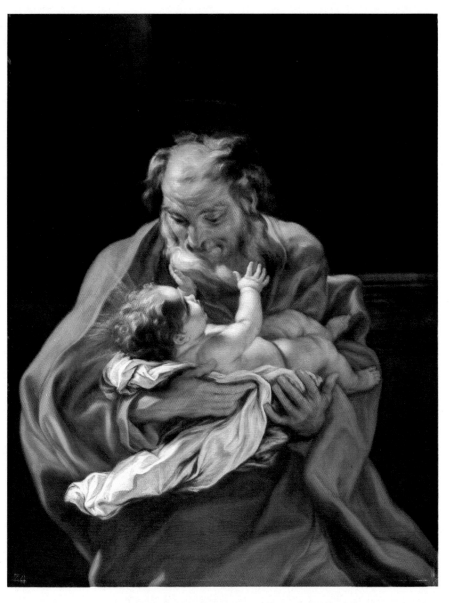

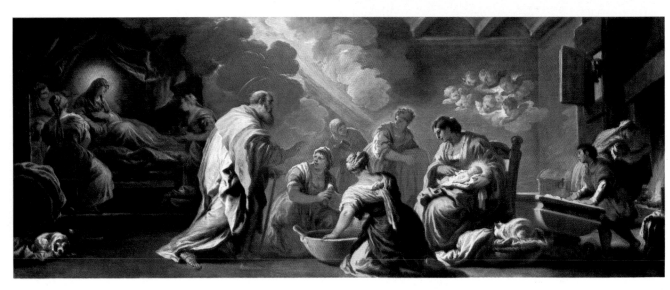

Luca Giordano, 1632–1705 *The Nativity of the Virgin*
*c.*1696–8 Oil on canvas 106.6 × 259.1cm

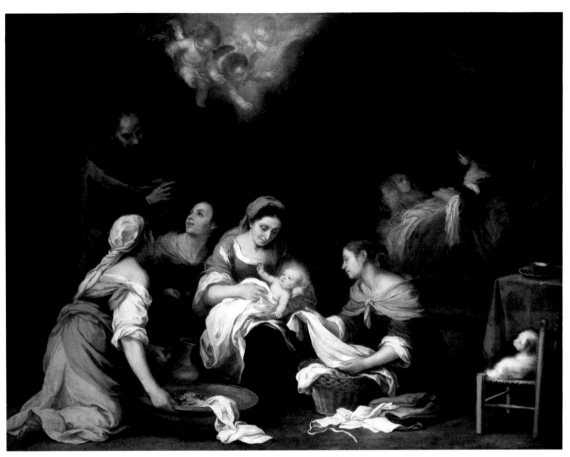

Bartolome Esteban Murillo, 1617–82 *The Birth of St. John the Baptist*
*c.*1655 Oil on canvas 146.7 × 188cm

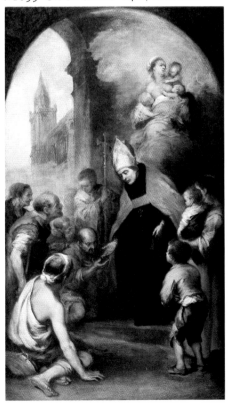

Bartolome Esteban Murillo, 1617–82
St. Thomas of Villanueva Giving Alms to the Poor
1678 Oil on canvas 130.2 × 74.9cm

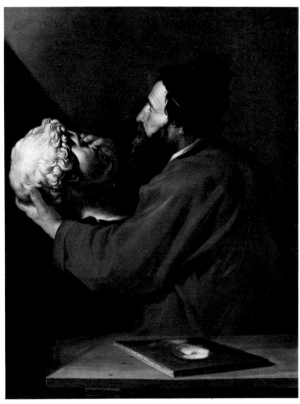

Jusepe de Ribera, 1588–1652 *The Sense of Touch*
Oil on canvas 111.8 × 86.4cm

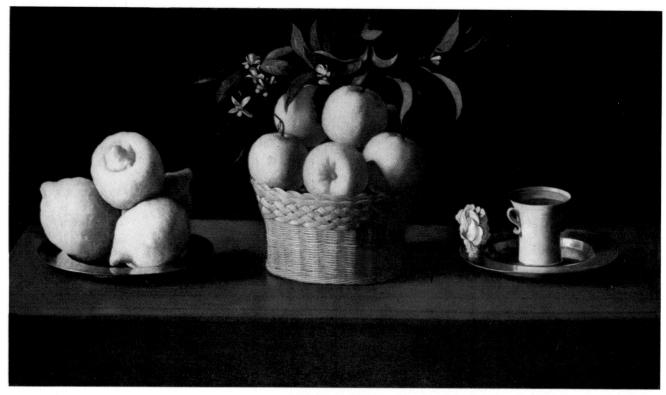

Francisco de Zurbaran, 1598–1664 *Still Life: Lemons, Oranges, and a Rose*
1633 Oil on canvas 61.6 × 109.2cm

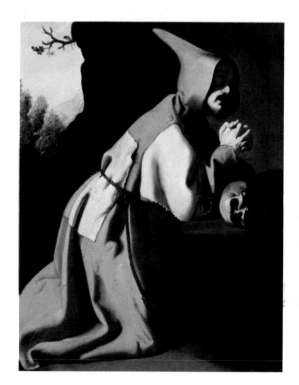

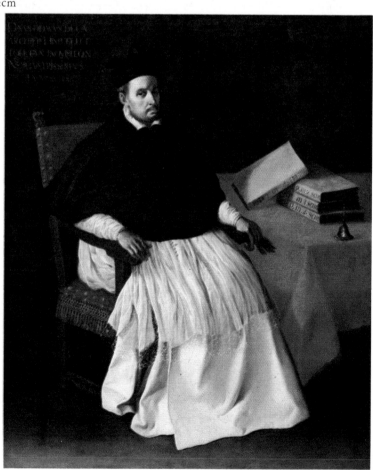

Francisco de Zurbaran, 1598–1664 *St. Francis in Prayer*
*c.*1638–9 Oil on canvas 117.5 × 90.2cm

Francisco de Zurbaran, 1598–1664 *Fray Diego Deza*
*c.*1630 Oil on canvas 166.4 × 137.8cm

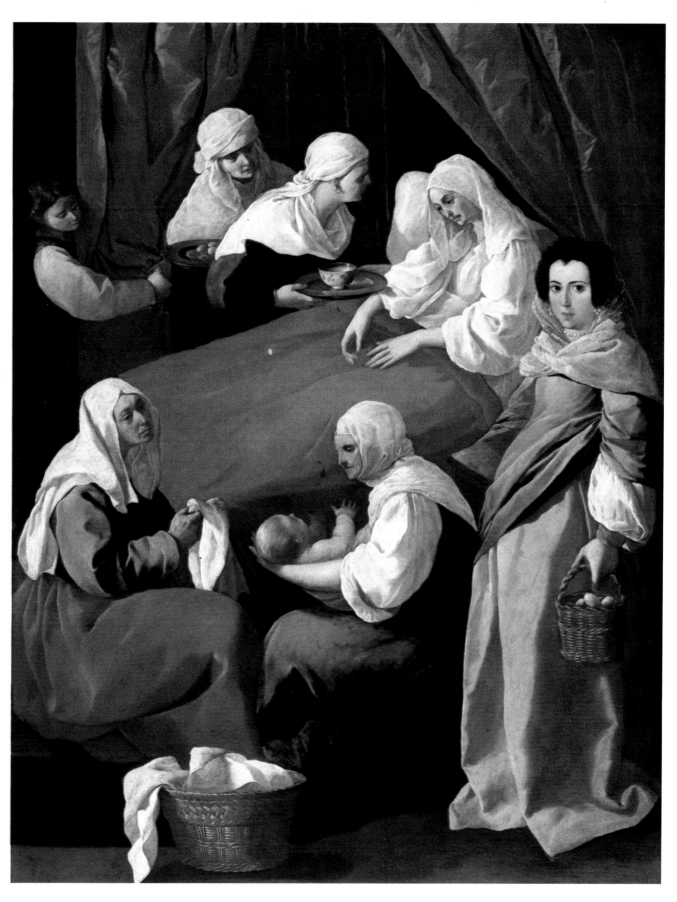

Francisco de Zurbaran, 1598–1664 *The Birth of the Virgin*
1627 Oil on canvas 141 × 109.2cm

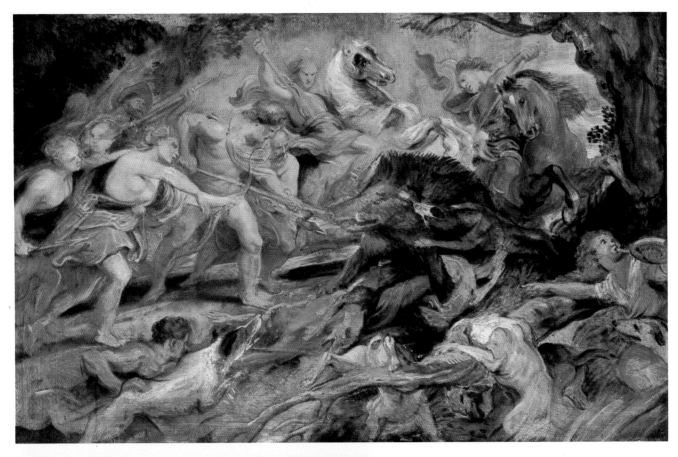

Sir Peter Paul Rubens, 1577–1640 *Meleager and
Atalanta and the Hunt of the Calydonian Boar*
c. 1620 Oil on panel 47.6 × 74cm

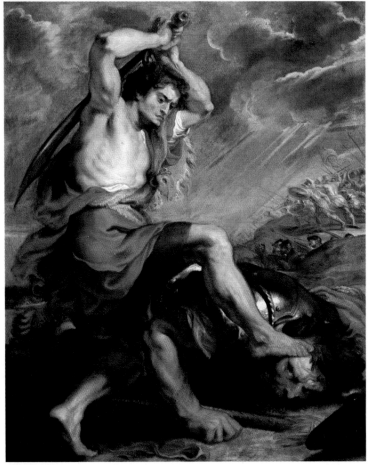

Sir Peter Paul Rubens, 1577–1640
David Slaying Goliath
c. 1630 Oil on canvas 121.9 × 99.1cm

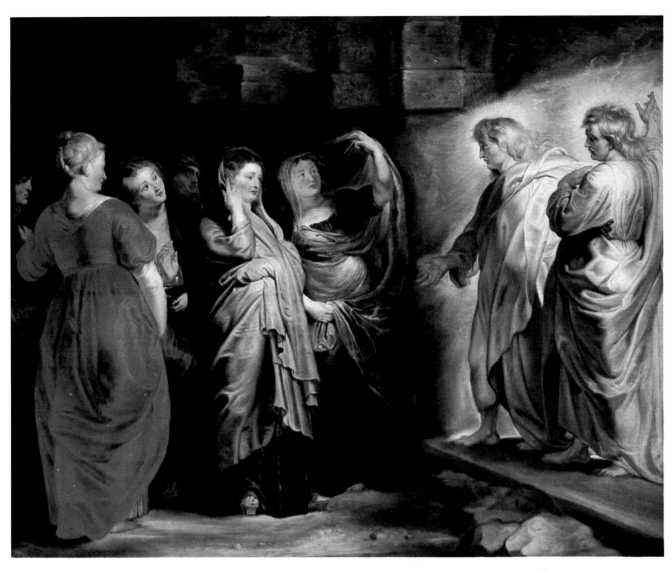

Sir Peter Paul Rubens, 1577–1640 *The Holy Women at the Sepulchre*
*c.*1611–14 Oil on panel 87.6 × 107.3cm

Sir Peter Paul Rubens, 1577–1640
Saint Ignatius of Loyola
*c.*1620–2 Oil on canvas 223.5 × 138.4cm

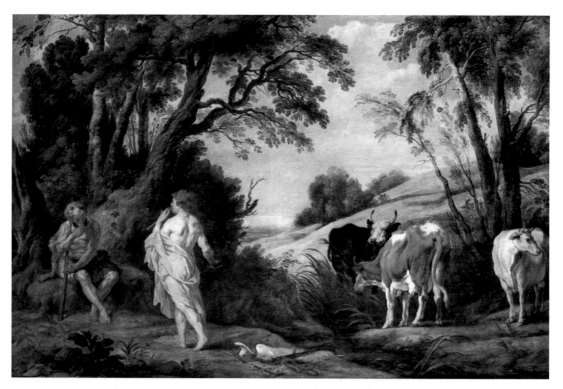

Jacob Jordaens, 1593–1678 *Mercury and Argus* (Landscape by Jan Wildens, 1586–1653)
Oil on canvas 121.3 × 184.8cm

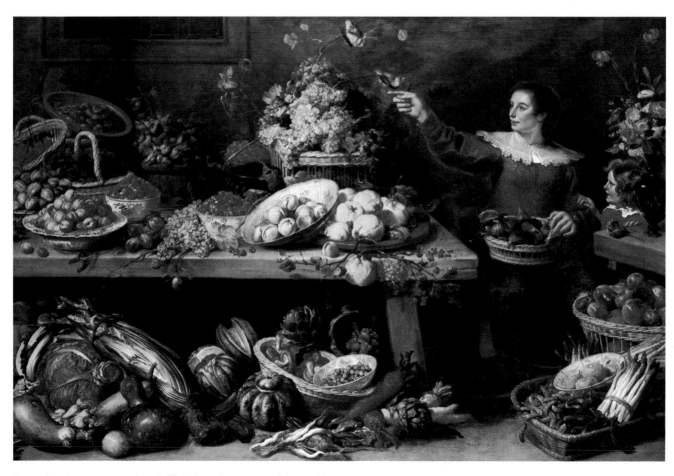

Frans Snyders, 1579–1657 *Still Life with Fruits and Vegetables*
(Figures by Cornelis de Vos, 1585–1651) Oil on canvas 174.4 × 256.5cm

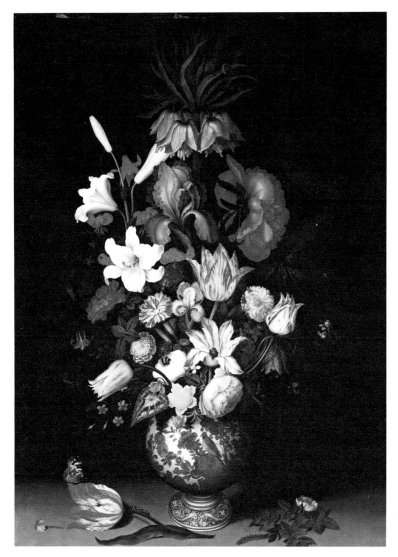

Ambrosius Bosschaert the Elder, 1573–1621
Large Bouquet in a Gilt-Mounted Wan-Li Vase
Oil on panel 80 × 54.6cm

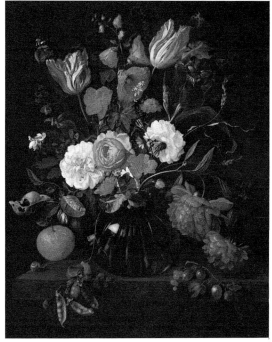

Jan Davidzoon de Heem, 1606– 83/4 *Vase of Flowers*
1654 Oil on canvas 67.3 × 55.2cm

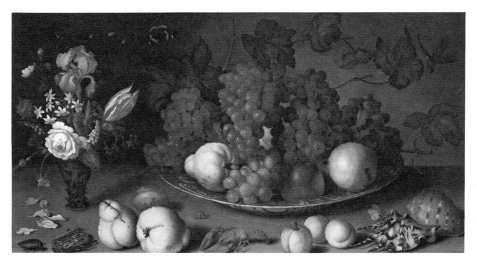

Balthasar van der Ast, 1593–1656
Still Life with Fruits and Flowers
Oil on panel 41.3 × 74.9cm

Ambrosius Bosschaert the Elder, 1573–1621
Flowers in a Vase
Oil on copper 31.1 × 22.9cm

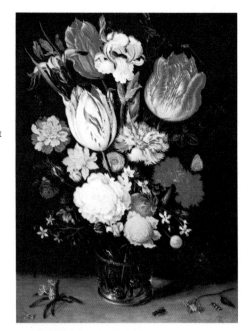

Jan Brueghel, 1568–1625 *An Arrangement of Flowers*
Oil on panel 53.3 × 42.5cm

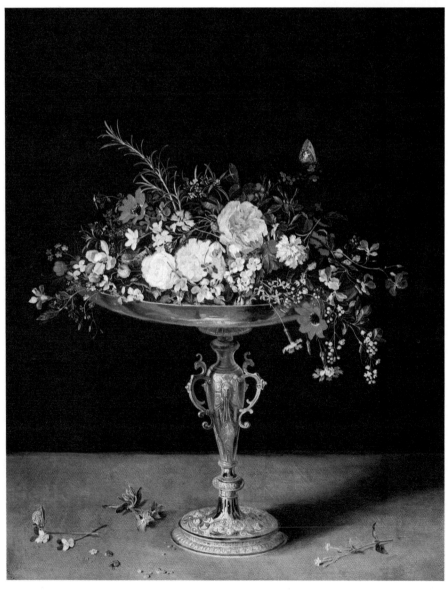

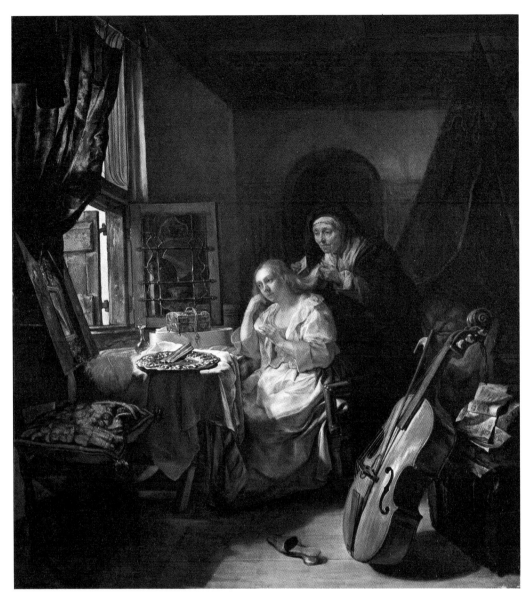

Gabriel Metsu, 1629–67 *Woman at Her Toilette*
Oil on panel 61 × 54.6cm

Jan van der Heyden, 1637–1712 *Library Interior with Still Life*
1711–12 Oil on canvas 57.2 × 68.6cm

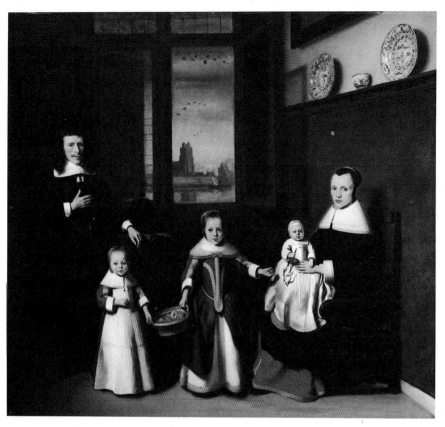

Nicolaes Maes, 1634–93 *A Family Portrait with a View of Dordrecht*
1656 Oil on canvas 110.5 × 120cm

Thomas de Keyser, 1596/7–67
Portrait of a Gentleman and His Son
1631 Oil on canvas 63.5 × 48.9cm

Gerard Dou, 1613–75 *Portrait of a Lady
of Rank*
*c.*1635–40 Oil on panel 48.3 × 38.1cm

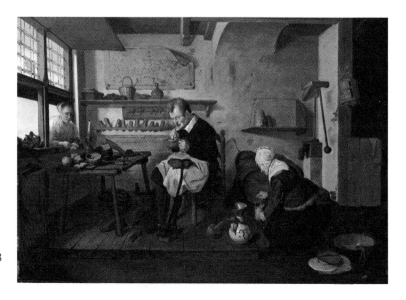

Quirin Gerritszoon van Brekelenkam, 1620–68
Cobbler's Shop
Oil on panel 59.1 × 82.2cm

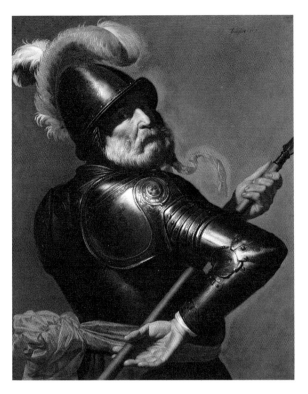

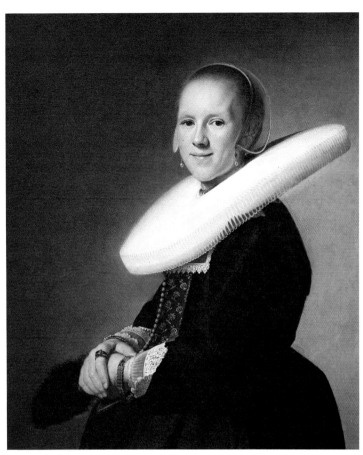

Jan van Bylert, 1608–71 *Portrait of an Officer in Armour*
Oil on canvas 85.1 × 69.9cm

Johannes Corneliszoon Verspronck, 1597–1662 *Portrait of a Lady*
(said to be Trijntgen Adamsdr, wife of Thomas Wyck)
1641 Oil on canvas 77.5 × 64.8cm

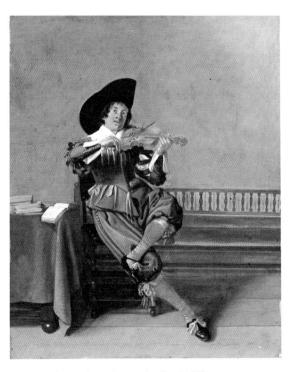

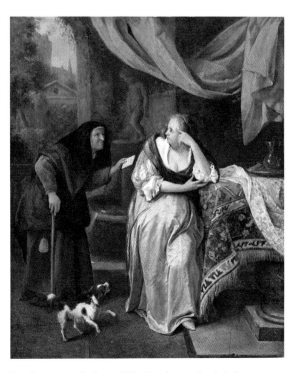

School of Haarlem, *Portrait of a Fiddler*
Oil on panel 36.8 × 29.2cm

Jan Steen, *c.* 1626–79 *The Loveletter (Bathsheba)*
Late 1660s Oil on panel 38.1 × 31.8cm

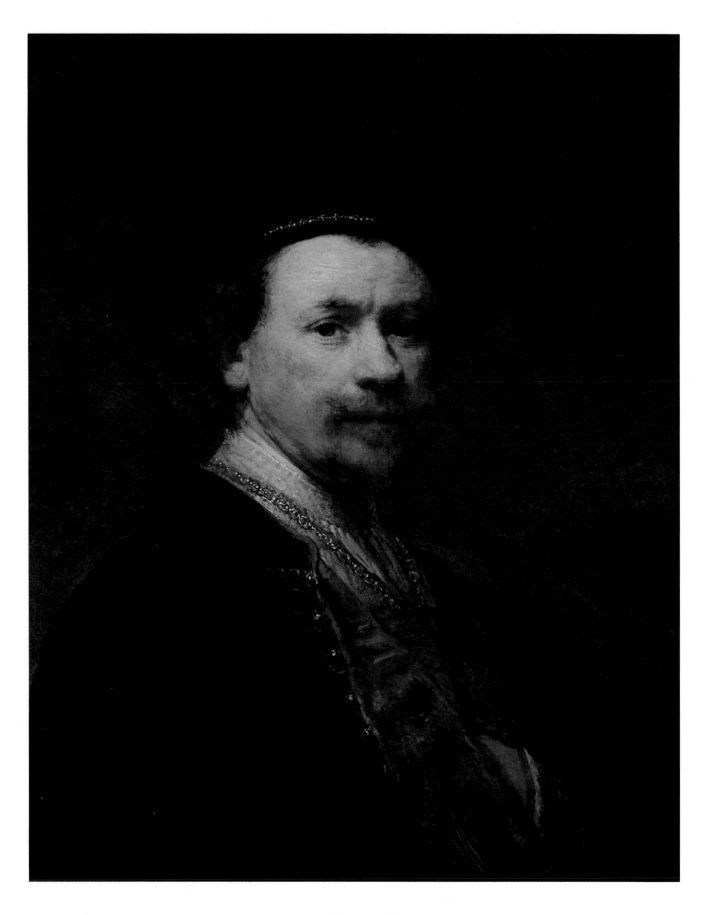

Rembrandt Harmenszoon van Rijn, 1606– 69 *Self-Portrait*
*c.*1636– 8 Oil on panel 63.5 × 50.8cm

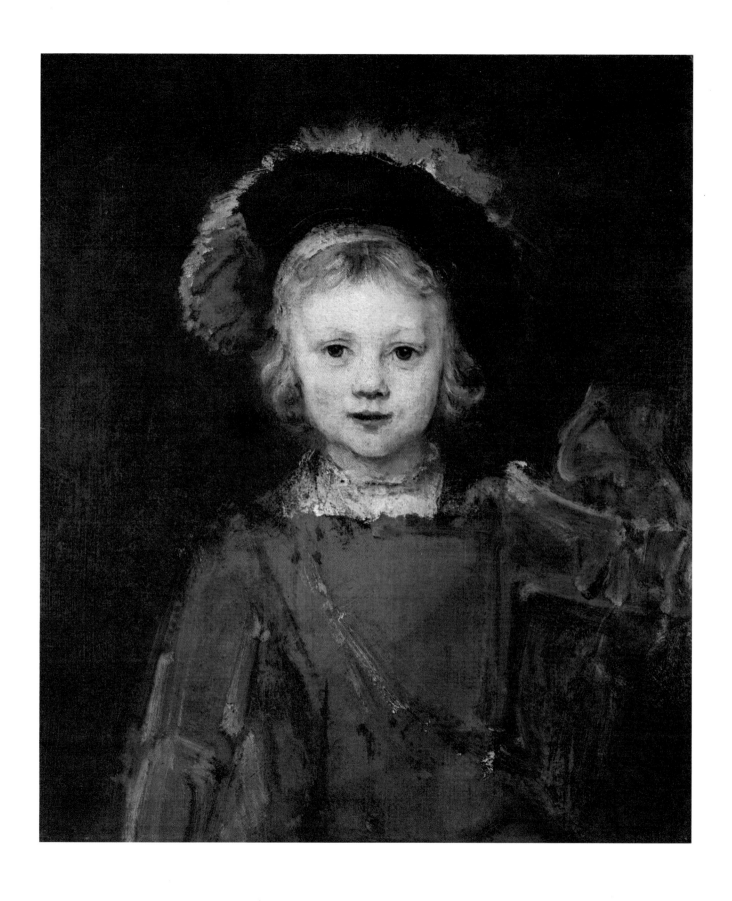

Rembrandt Harmenszoon van Rijn, 1606– 69 *Portrait of the Artist's Son, Titus*
*c.*1645– 50 Oil on canvas 64.8 × 55.9cm

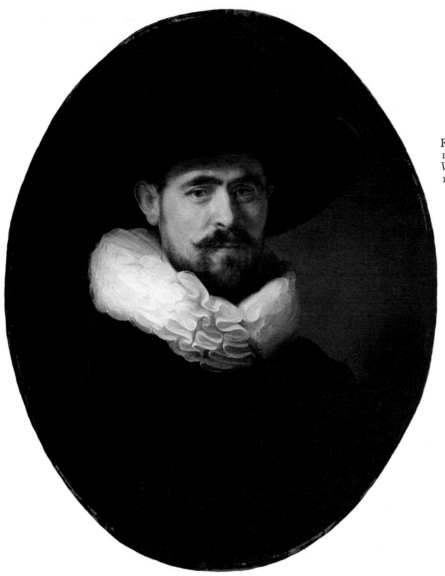

Rembrandt Harmenszoon van Rijn,
1606– 69 *Portrait of a Bearded Man in a
Wide-Brimmed Hat*
1633 Oil on panel 69.9 × 55.2cm (oval)

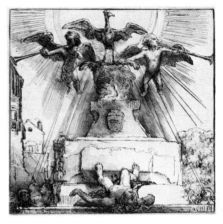

Rembrandt Harmenszoon van Rijn,
1606– 69 *The Phoenix; or the Statue
Overthrown: An Allegory of Doubtful
Meaning*
1658 Etching and drypoint, only state
Plate: 18.1 × 18.4cm
Sheet: 18.4 × 18.7cm

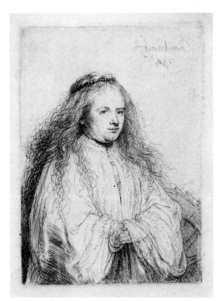

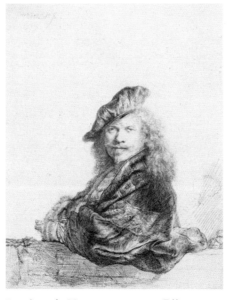

Rembrandt Harmenszoon van Rijn,
1606– 69 *Study of Saskia as St.
Catherine (The 'Little Jewish Bride')*
1638 Etching, only state 10.95 × 7.9cm

Rembrandt Harmenszoon van Rijn,
1606– 69 *Rembrandt Leaning on a Stone-Sill:
Half Length*
1639 Etching, 1st state of 2 21 × 15.9cm

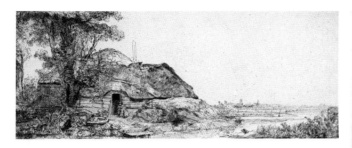

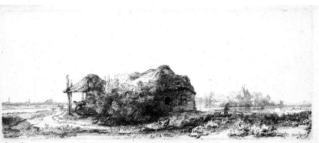

Rembrandt Harmenszoon van Rijn, 1606– 69
Landscape with a Cottage and a Large Tree
1641 Etching, only state 12.45 × 32cm

Rembrandt Harmenszoon van Rijn, 1606– 69
Landscape with a Cottage and Hay Barn: Oblong
1641 Etching, only state 13 × 32.15cm

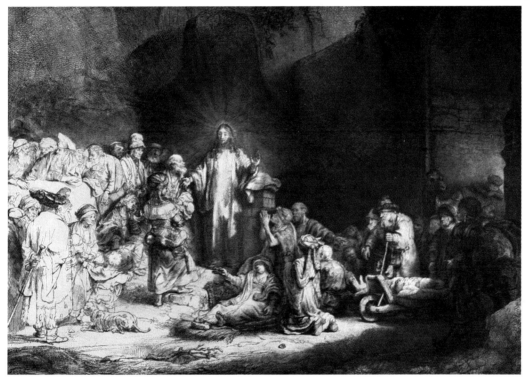

Rembrandt Harmenszoon van Rijn, 1606– 69
Christ, with the sick around him, receiving little children (The Hundred Guilder Print)
c. 1649 29.8 × 40.6cm

Rembrandt Harmenszoon van Rijn, 1606– 69
The Three Trees
1643 Etching, only state 18 55 × 27.9cm

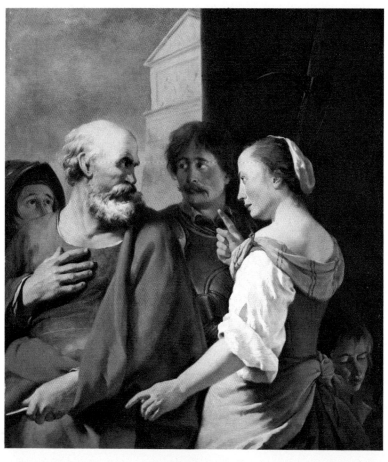

Karel Dujardin, 1622–78 *The Denial of Peter*
Oil on canvas 119.4 × 104.1cm

Matthais Stomer, *c.*1600–*c.*1650 *The Mocking of Christ*
*c.*1633–9 Oil on canvas 109.2 × 160.3cm

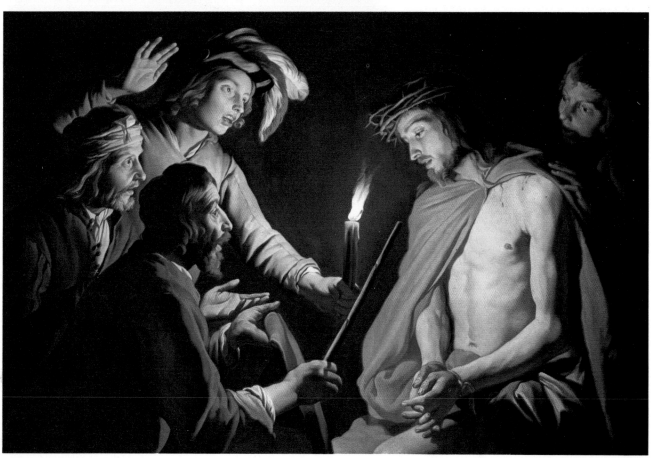

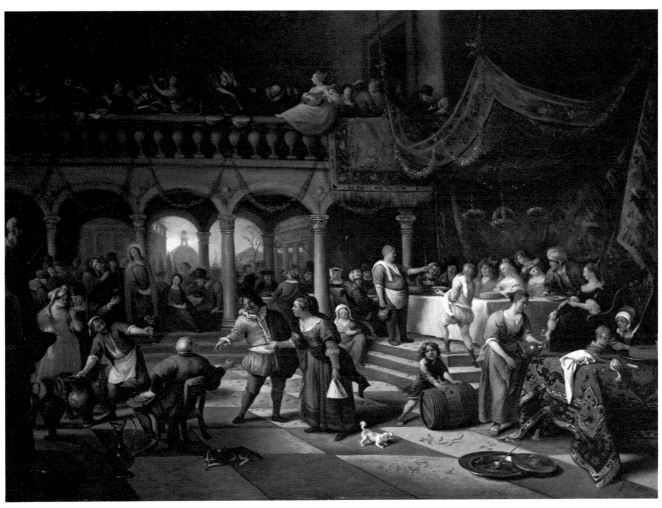

Jan Steen, *c.* 1626–79 *The Wedding Feast at Cana*
1676 Oil on canvas 76.8 × 106.7cm

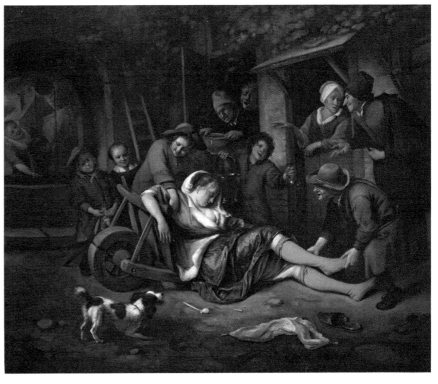

Jan Steen, *c.* 1626–79 *Wine is a Mocker*
Oil on canvas 87.6 × 104.1cm

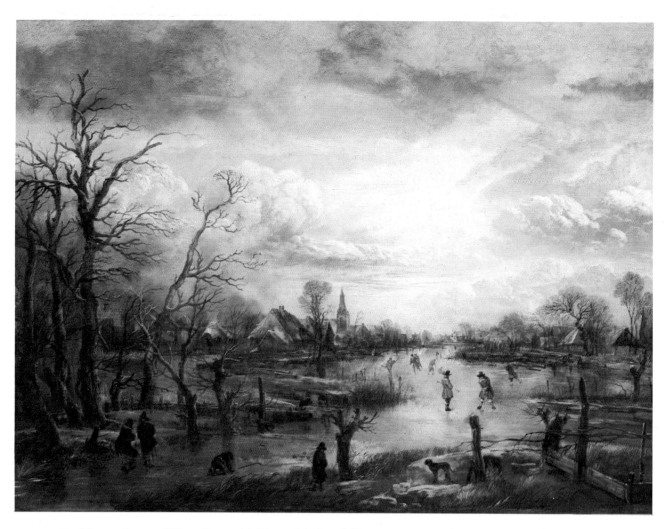

Aert van der Neer, 1603–77 *Winter Scene with Figures Playing Golf*
Oil on canvas 56.5 × 77.5cm

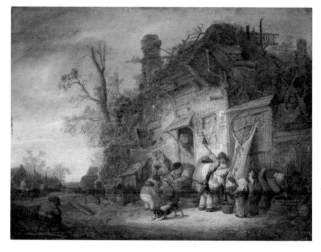

Isaac van Ostade, 1621–49 *Peasants Outside a Farmhouse Butchering Pork*
1641 Oil on panel 49.5 × 66cm

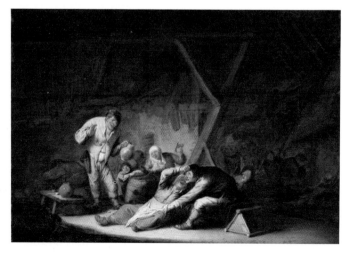

Adriaen van Ostade, 1610–85 *Carousing Peasants in an Inn*
Oil on panel 41.9 × 58.7cm

60

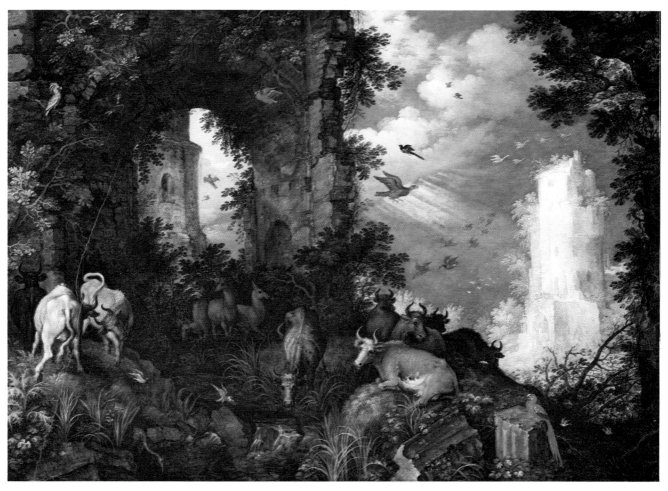

Roeland Savery, 1576–1639 *Landscape with Animals and Birds*
1624 Oil on panel 52.7 × 76.2cm

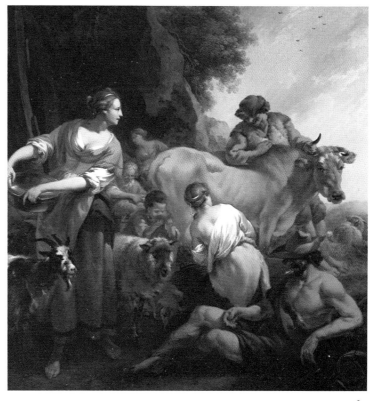

Nicolaes Berchem, 1620–83 *A Pastoral Scene*
1679 Oil on panel 67.5 × 64.1cm

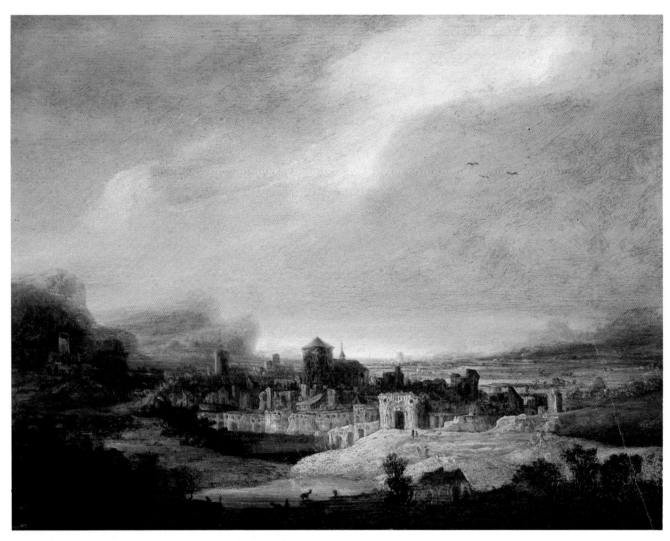

Jan Lievens, 1607–74 *Panoramic Landscape*
1640 Oil on panel 38.7 × 49.5cm

Aelbert Cuyp, 1620–91 *Evening in
the Meadows*
Oil on canvas 106 × 138.4cm

Salomon van Ruysdael, 1602/3–70 *Landscape with Sandy Road*
1628 Oil on panel 27.3 × 38.1cm

Salomon van Ruysdael, 1602/3–70 *Halt in Front of an Inn*
1643 Oil on panel 61 × 91.4cm

Jacob van Ruisdael, c. 1628–82 *Three Old Beech Trees*
c. 1665–70 Oil on canvas 138.1 × 173cm

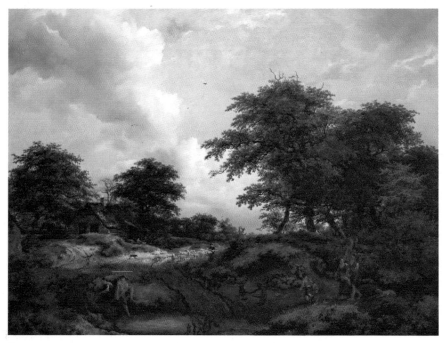

Jacob van Ruisdael, c. 1628–82 *Woody
Landscape with a Pool and Figures*
Oil on panel 69.9 × 92.1cm

64

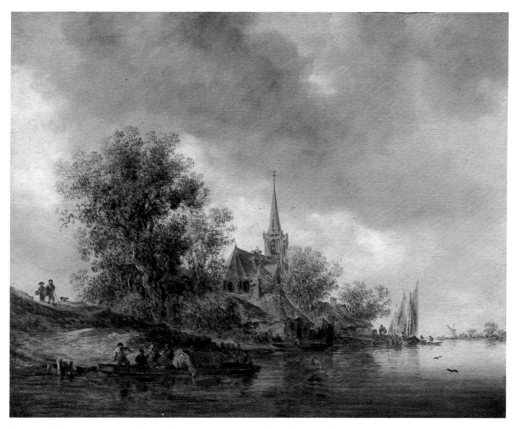

Jan van Goyen, 1596–1665 *A River Landscape with a View of Overschie*
1642 Oil on panel 31.1 × 38.7cm

Abraham Storck, 1630–1710 *Vessels Offshore in a Calm*
Oil on canvas 39.4 × 50.8cm

Louise Moillon, 1610–96 *Still Life with Cherries,*
Strawberries, and Gooseberries
1630 Oil on panel 32.4 × 48.9cm

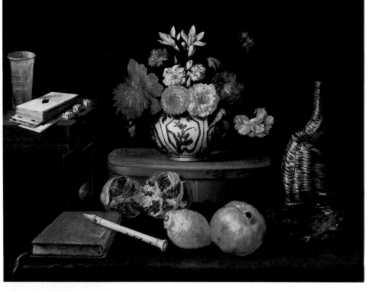

Jacques Linard *c.* 1600–45 *Still Life: The*
Five Senses with Flowers
1639 Oil on canvas 54.6 × 67.9cm

Sebastian Stoskopff, *c.* 1597–1657 *Still Life*
with Empty Glasses
1644 Oil on canvas 86.4 × 109.9cm

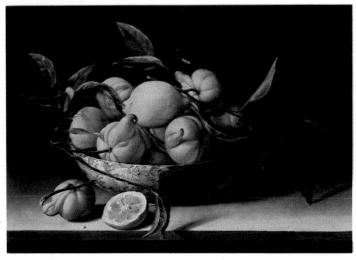

Louise Moillon, 1610–96 *Still Life with Bowl of*
Curaçao Oranges
1634 Oil on panel 46.4 × 64.8cm

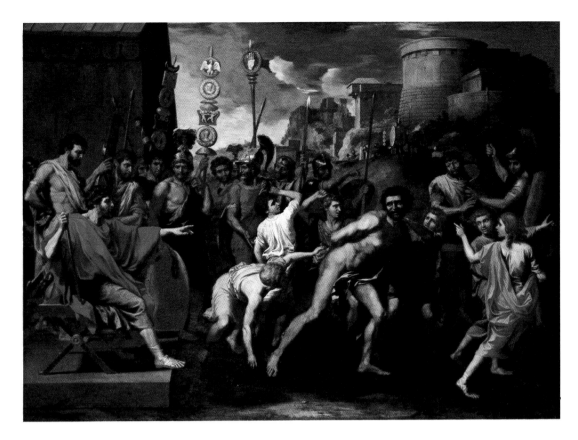

Nicolas Poussin, 1593/4–65 *Camillus and the Schoolmaster of Falerii*
*c.*1635–40 Oil on canvas 80.8 × 133cm

Claude Gellée, called Le Lorrain, 1600–82 *Landscape with a Piping Shepherd*
*c.*1629–32 Oil on canvas 66 × 95.3cm

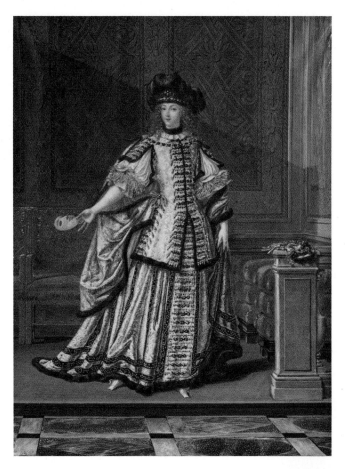

Joseph Werner, 1637–1710
Mlle. de la Vallière in Costume
*c.*1663 Gouache on parchment
35.9×26.9cm

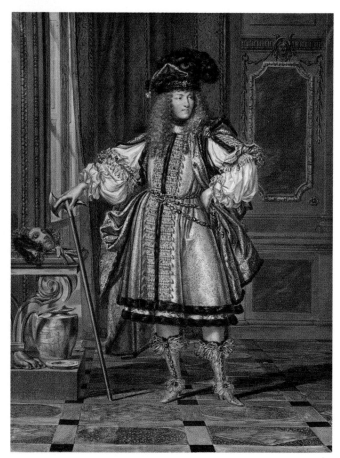

Joseph Werner, 1637–1710
Louis XIV in Costume
*c.*1663 Gouache on parchment
36.2×26.9cm

68

The Eighteenth Century

As travel became easier in eighteenth-century Europe and journeys could be undertaken for pleasure and instruction, the young and affluent set out on 'grand tours' of the continent. One of the great attractions was Venice, with its incomparable architecture and waterways and remarkable marine setting. Luca Carlevarijs was one of the first to fulfil the resultant demand for topographical paintings, but it was Giovanni Antonio Canal, known as 'Canaletto', who first put on canvas the crystalline precision of detail of Venetian architecture and life that really appealed to visitors, particularly those from England. Francesco Guardi and his brother Antonio, who both knew Canaletto, painted similar scenes, but their view paintings—the group were collectively known as the 'vedutists' (view painters)—are much freer in execution and captured atmosphere with a much more sketch-like application of paint.

Francesco Guardi was brother-in-law to Giovanni Battista Tiepolo, who excelled in vast decorative paintings with allegorical themes, and became the most renowned painter in Venice, if not in Italy, in the eighteenth century. *The Triumph of Virtue and Nobility over Ignorance* was painted for a ceiling in the Palazzo Manin in Venice. The scene of imperious goddesses (Virtue and Nobility) accompanied by cherubs and Ignorance being vanquished by a little angel was thus intended to be seen from below as a vision above the spectators' heads.

In contrast to this sumptuous, large-scale accomplishment, let us move from Italy to France, to Watteau's tiny, jewel-like *Reclining Nude* of 1715, painted when the artist was thirty. He had begun his career earlier eking out a living as a copyist of Dutch paintings, but by now had developed a consummate style of his own, which made him the leading painter in France. Jean-Baptiste Pater was Watteau's only pupil, and after his master's early death in 1721 carried on in the tradition of *fête galante* which Watteau had popularized. Chardin, on the other hand, turned back for inspiration to seventeenth-century Holland and succeeded in imbuing *genre* paintings with a fresh dignity and introspection, and an astonishing control of light and shade. François Boucher began his professional career by making prints after paintings and drawings by Watteau. By the 1740s he dominated French painting, was appointed court painter, and was lavishly patronized by Madame de Pompadour, mistress of Louis XV. Boucher's speciality was painting radiant and beautiful female nudes, as exemplified in *Vertumnus and Pomona*. He also endowed peasant figures, such as the enchanting mother in *La Belle Villageoise*, with a new dignity and vitality. Jean-Honoré Fragonard trained under both Chardin and Boucher, before spending several years in Rome. The demand for paintings depicting the sensual, often light-hearted, world of Boucher and Fragonard was brought to an abrupt end by the French Revolution.

Marie-Louise-Elisabeth Vigée-Lebrun had, in fact, risen to fame through her portraits of Queen Marie Antoinette, and was consequently forced to flee from France at the time of the Revolution. It was during her exile in Vienna in 1793 that she painted *Theresa, Countess Kinsky*. The painting clearly foreshadowed the style of romanticism in portraiture that became very popular in Europe in the early nineteenth century, and is in remarkable contrast to the formalism of the portraiture in the grand manner of Largillière and Rigaud earlier in the same century.

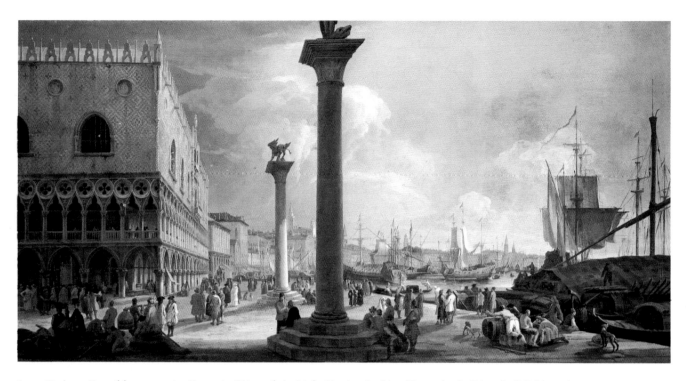

Luca Carlevarijs, 1665–1731 *An Extensive View of the Molo, Venice, Looking Towards the Riva degli Schiavoni*
Oil on canvas 85.7 × 163.8cm

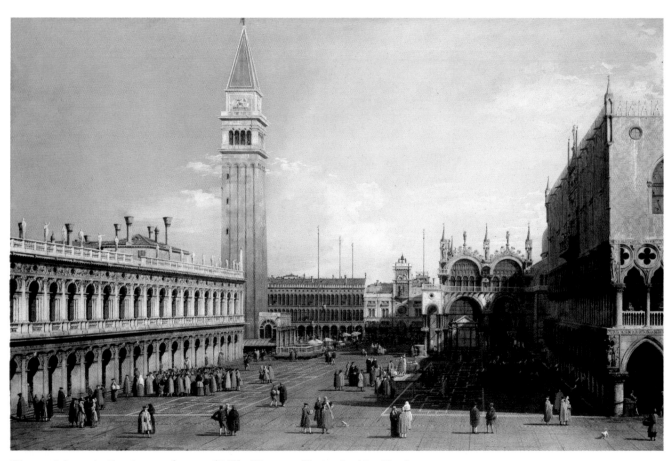

Giovanni Antonio Canaletto, 1697–1768 *The Piazzetta, Venice, Looking North*
Before 1755 Oil on canvas 76.2 × 119.4cm

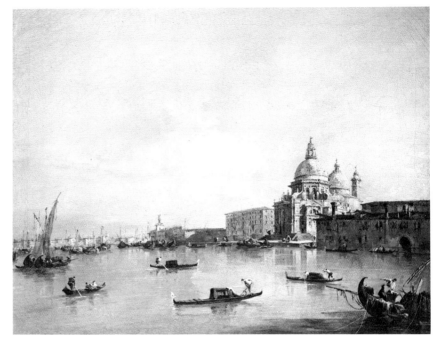

Francesco Guardi, 1712–93 *View of the
Santa Maria della Salute with the Dogana
di Mare*
Oil on canvas 40.9 × 51.1cm

Francesco Guardi, 1712–93 *A View of the
Rialto, Venice, from the Grand Canal*
Oil on canvas 43.2 × 62.9cm

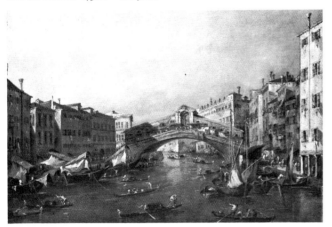

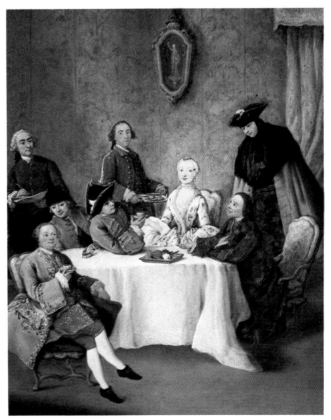

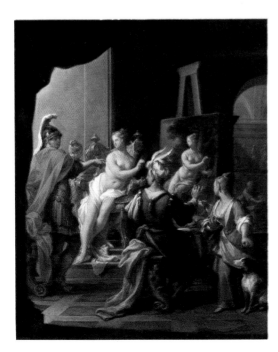

Pietro Longhi, 1702–85 *Artist Sketching an Elegant
Company*
*c.*1760 Oil on canvas 61.3 × 49.5cm

Francesco Trevisani, 1656–1746 *Apelles Painting
Campaspe*
1720 Oil on canvas 74.9 × 60.3cm

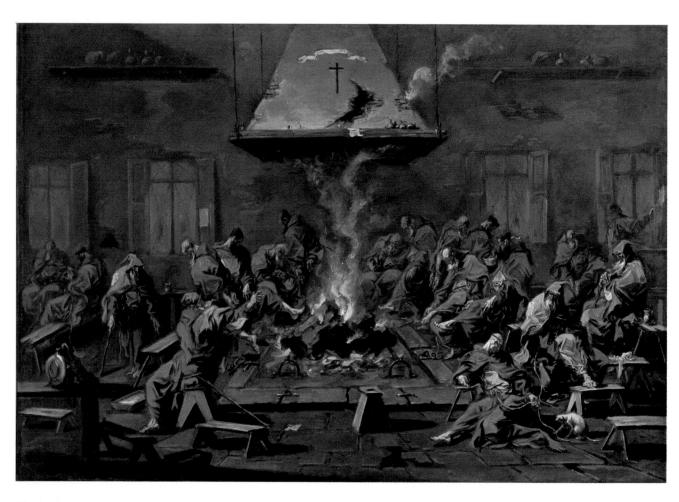

Alessandro Magnasco, 1677–1749 *Interior with Monks*
Oil on canvas 93.3 × 132.7cm

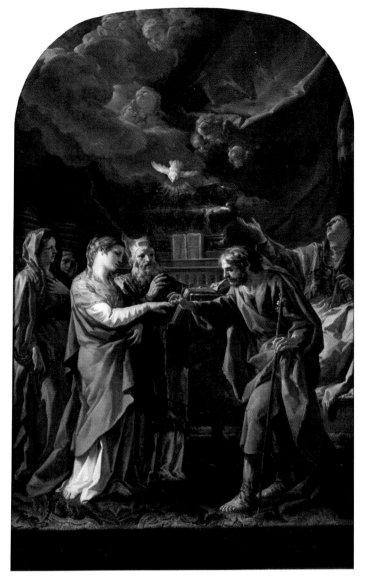

Corrado Giaquinto, 1699–c. 1765
The Marriage of the Virgin
Oil on canvas 284.5 × 177.8cm

Giovanni Paolo Pannini,
1691–1765 *Interior of Saint Peter's,
Rome*
1735 Oil on canvas 153 × 219.7cm

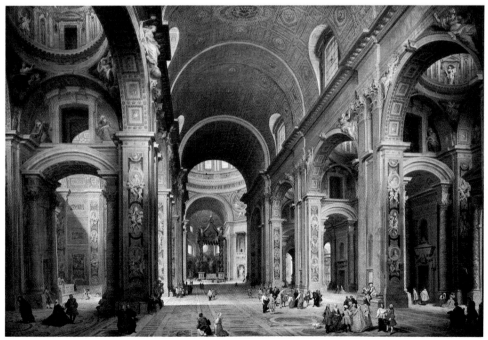

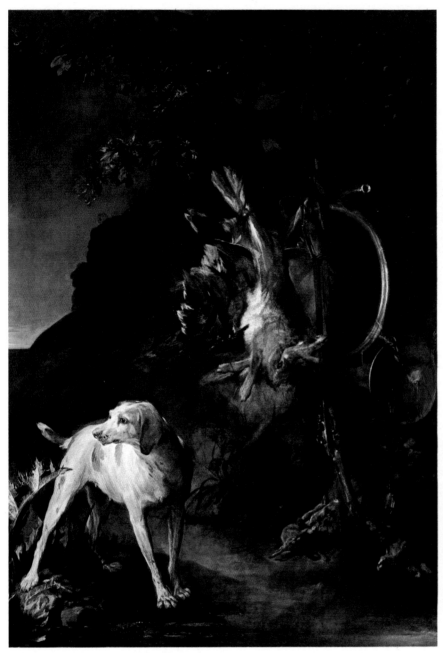

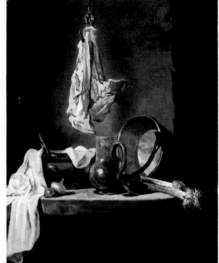

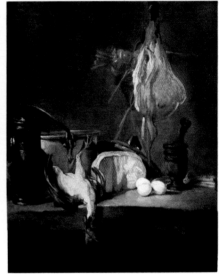

Jean-Baptiste Siméon Chardin, 1699–1779 *Dog and Game*
1730 Oil on Canvas 192.4 × 139.1cm

Jean-Baptiste Siméon Chardin,
1699–1779 *A Pair of Still Lifes*
*c.*1728–30 Oil on canvas 40 × 31.4cm
each

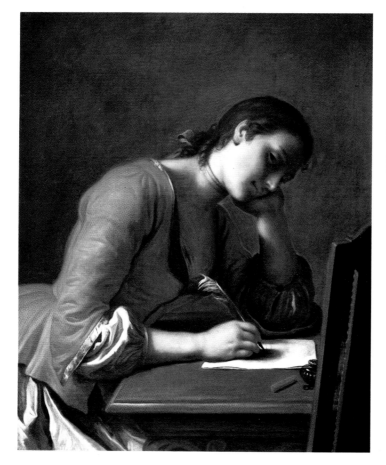

Pietro Antonio Rotari, 1707–62
Young Girl Writing a Love Letter
*c.*1755 Oil on canvas
82.6 × 66.7cm

Henri-Horace Roland de la Porte, *c.*1724–93 *Still Life*
*c.*1765 Oil on canvas 52.9 × 64.8cm

Pierre Charles Duvivier, 1716–88 *An Architect's Table*
1772 Oil on canvas 102.5 × 78.7cm

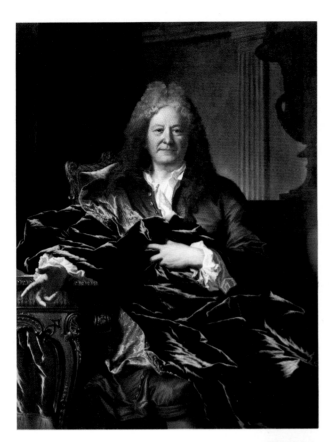

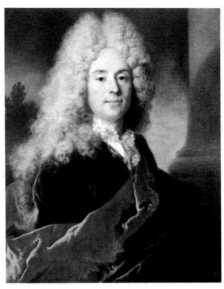

Hyacinthe Rigaud, 1659–1743 *Portrait of Antoine Pâris, Conseiller d'Etat* c.1703–5 Oil on canvas 148.6 × 114.3cm

Nicolas de Largillière, 1656–1746 *The Marquis d'Havrincourt* Oil on canvas 81.3 × 64.8cm

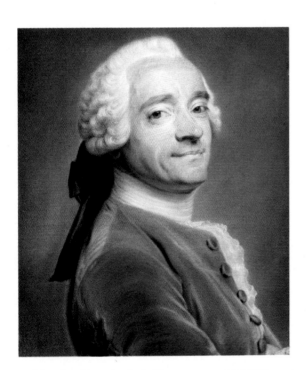

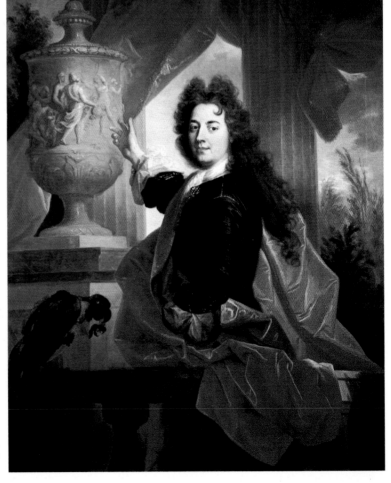

Maurice Quentin de la Tour, 1704–88 *Self-Portrait* 1764 Pastel on paper 44.5 × 36.8cm

Nicolas de Largillière, 1656–1746 *Portrait of Pierre Lepautre, Sculptor* 1689 Oil on canvas 164.4 × 128.9cm

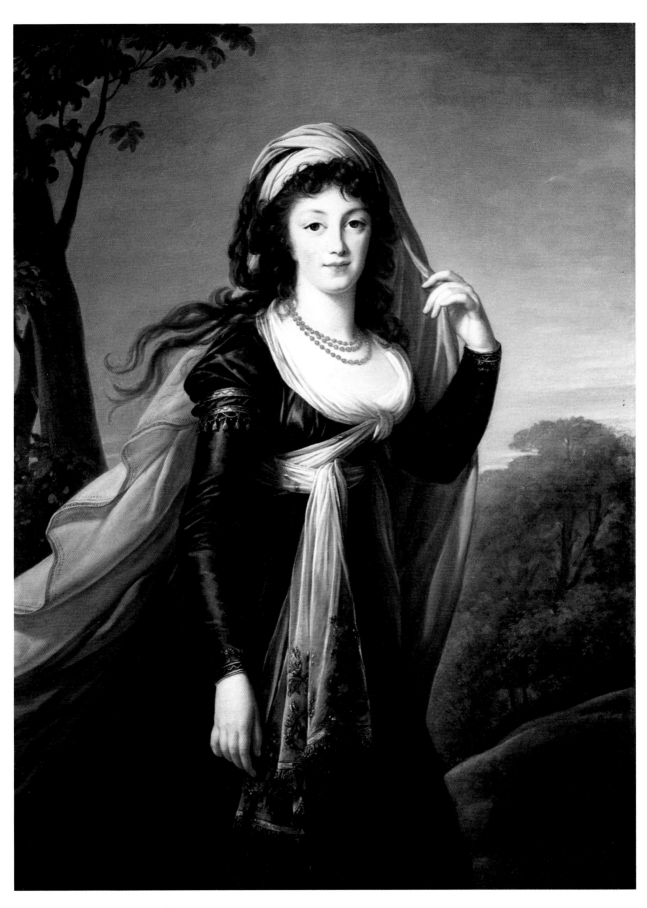

Marie-Louise-Elisabeth Vigée-Lebrun, 1755–1842 *Theresa, Countess Kinsky*
1793 Oil on canvas 134.6 × 99.1cm

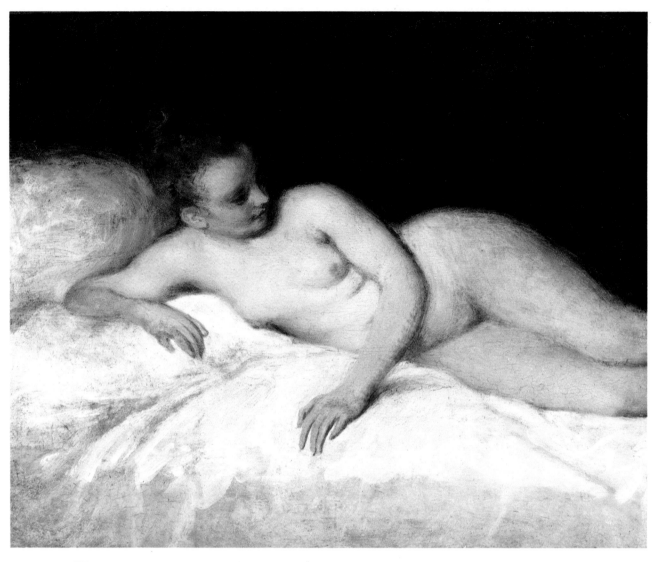

Antoine Watteau, 1684–1721 *Reclining Nude* c.1713–17 Oil on panel 14×17.1cm

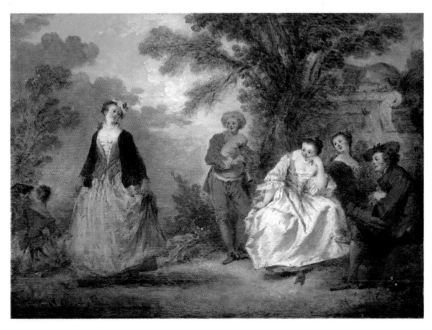

Jean-Baptiste Pater, 1695–1736 *Fête Galante* Oil on panel 19.9 × 27.3cm

François Boucher, 1703–70 *La Belle Villageoise*
*c.*1732 Oil on canvas 41.9 × 32cm

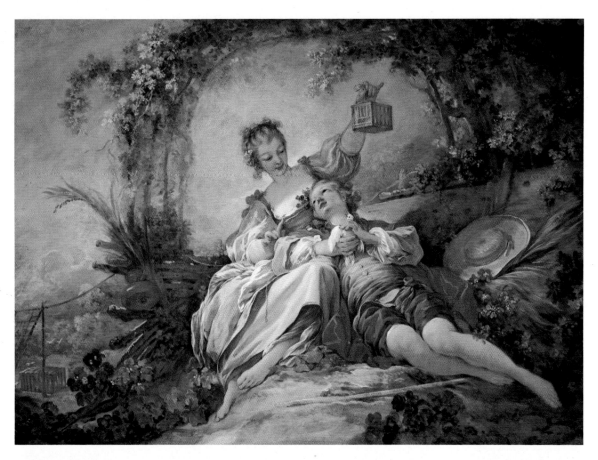

Jean-Honoré Fragonard, 1732–1806 *The Bird Cage, or The Happy Lovers* c.1760–5 Oil on canvas 90.2 × 119.4cm

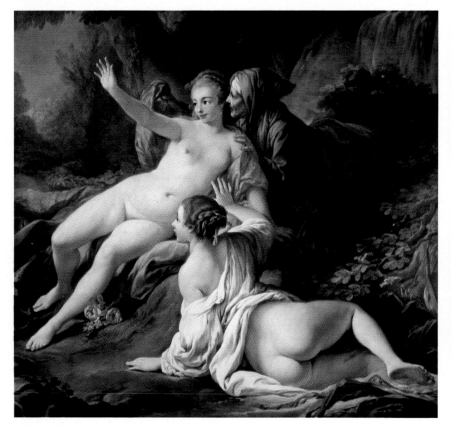

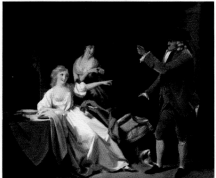

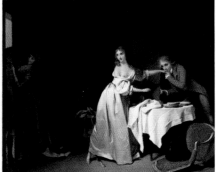

Louis Leopold Boilly, 1761–1845
The Interrupted Supper (pair)
Oil on canvas 38.1 × 45.7cm each

François Boucher, 1703–70 *Vertumnus and Pomona*
c.1740–5 Oil on canvas 159.4 × 168.5cm

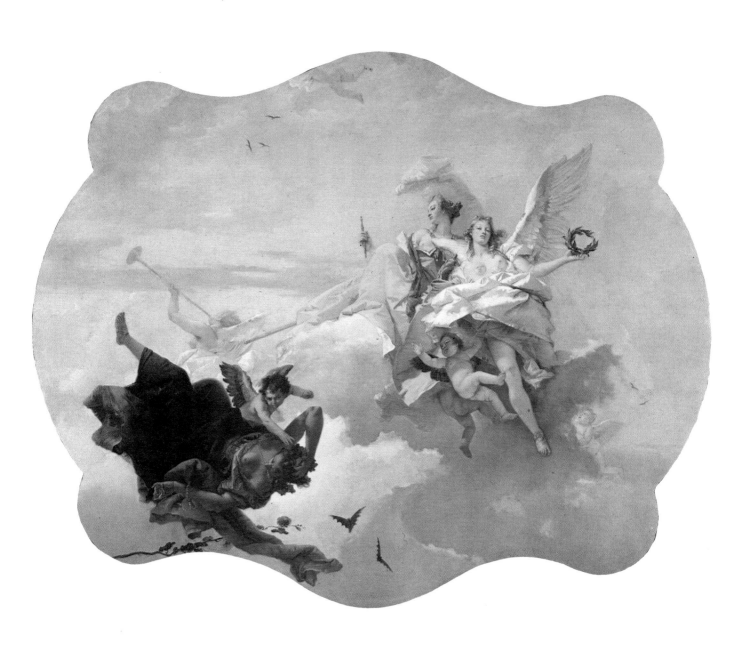

Giovanni Battista Tiepolo, 1696–1770 *The Triumph of Virtue and Nobility over Ignorance*
c. 1740– 50 Oil on canvas (ceiling) 320 × 392.4cm
Ceiling painted for the Palazzo Manin, Venice

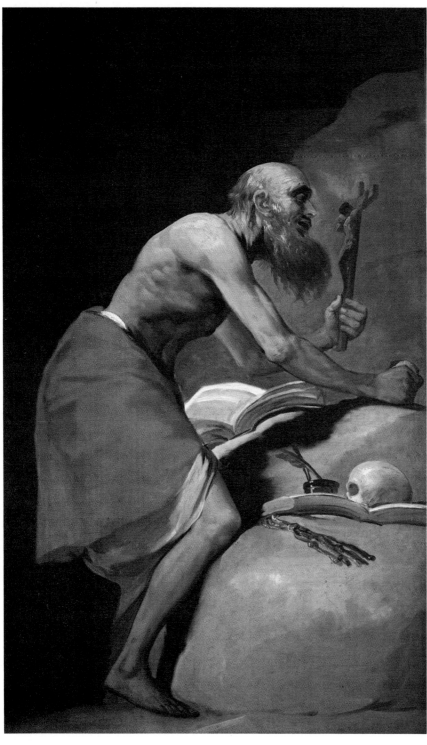

Francisco de Goya y Lucientes, 1746–1828 *Saint Jerome*
1798 Oil on canvas 190.5 × 114.3cm

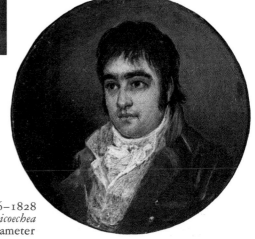

Francisco de Goya y Lucientes, 1746–1828
Portrait of Martin Miguel de Goicoechea
1805–6 Oil on copper, roundel 7.9cm diameter

Francisco de Goya y Lucientes,
1746–1828 *Los Caprichos: Plate 16,
For Heaven's Sake: And It was Her
Mother*
Working Proof, *c.*1798

Etching with aquatint, dry point and
burin, first edition with
contemporary colouring with
watercolour

Etching with aquatint, dry point and
burin, first edition, 1799
19.9 × 14.8cm

Francisco de Goya y Lucientes, 1746–1828 *The Bulls
of Bordeaux: Spanish Entertainment*
Proof, 1825 Lithographic crayon and scraper 29.8 × 40.6cm

Francisco de Goya y Lucientes, 1746–1828 *La Tauro-
maquia: Plate 2, Another Way of Hunting on Foot*
Proof, 1816 Etching, burnished aquatint, drypoint, and
burin 24.8 × 34.9cm

Francisco de Goya y Lucientes, 1746–1828
She is Timid About Taking Her Clothes Off (recto)
and *Masquerades of Holy Week in the Year '94* (verso)
Brush and grey wash drawing, heightened with
black 22.4 × 13.3cm

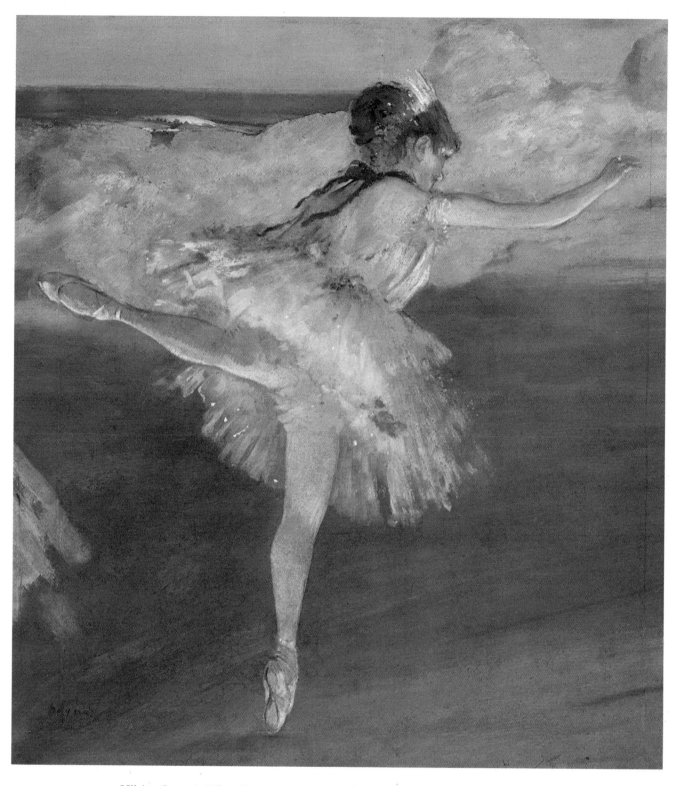

Hilaire-Germain-Edgar Degas, 1834–1917 *The Star: Dancer on Point* (detail)
c.1877–8 Gouache and pastel on paper 54.6 × 73.7cm

The Nineteenth Century

The most important development in painting during the nineteenth century was the emergence of a style described as 'Impressionism'. It was a term, like so many other stylistic labels, which was originally pejorative, coined by a hostile critic of Monet's painting *Impression, Sunrise* included in a Paris exhibition of 1874. Known today as the First Impressionist Exhibition, it displayed work by painters who had in preceding years developed a style totally at odds with that of the academic establishment which sponsored the yearly *Salons*. The leading figures in this new movement were Camille Pissarro, Edouard Manet, Alfred Sisley, Claude Monet, and Pierre Auguste Renoir.

The work of all these men is superbly represented in the Norton Simon Museum. The most striking canvas by Manet is that of *The Ragpicker*, conceived on a life-size scale and, surprisingly, inspired by Velasquez. There is also a portrait of Madame Manet and a very fine still life. We can follow Monet's stylistic evolution, however, in four canvasses. He painted the *Mouth of the Seine at Honfleur* when he was twenty-four and still completely unknown: it was, in fact, accepted by the *Salon* and received with acclaim. *The Entrance to the Port of Honfleur* was begun three years later in bolder, much more broken brush strokes. His style became even more relaxed and colourful in the *Artist's Garden at Vetheuil* of 1881 and achieves an almost spectral quality in *Rouen Cathedral, Tour d'Albane, Morning* of 1894, a subject the artist found so fascinating that he painted it at various times of the day with differing light and thus differing colours. It was almost as if an impression had given way to a vision.

Renoir had started his career very young as a porcelain decorator. He became interested in painting, and as this interest grew he developed a great enthusiasm for studying the older art in museums. He was also fascinated by aspects of the art of his own times, such as the realism of Courbet and the poetic moods of Corot's pictures, qualities which he tried to unite in his superb *Le Pont des Arts, Paris*. Later in his life, Renoir adopted a much gentler, more sensuous technique and became celebrated for his rendering of the female form, both clothed and nude.

Degas' subject matter was somewhat different from that of his contemporaries: the ballet, women at work and in domestic settings, the race course, cafés and the world of entertainment. He once described himself as a 'colourist in line', and his works in the Museum—in a variety of media—show him as both master draftsman and brilliant colourist. He was fascinated by movement, as can be seen in most of his work.

The Post-Impressionists are equally represented. Cézanne, the son of a prosperous banker in Aix-en-Provence, was a childhood friend of Zola. Through that relationship and a later friendship with Pissarro, Cézanne began a painting career. The portrait of his Uncle Dominique shows the impetuous, sensual qualities of the youthful painter. His mature work, on the other hand, such as *Farmhouse and Chestnut Trees at Jas-de-Bouffan* and *Tulips in a Vase*, demonstrate a classical restraint and severity which was to have a profound influence on later generations. How different are the vivid colours and emotional brushwork of van Gogh; the seeming exoticism of Gauguin; and the linear elegance in the paintings by Toulouse-Lautrec.

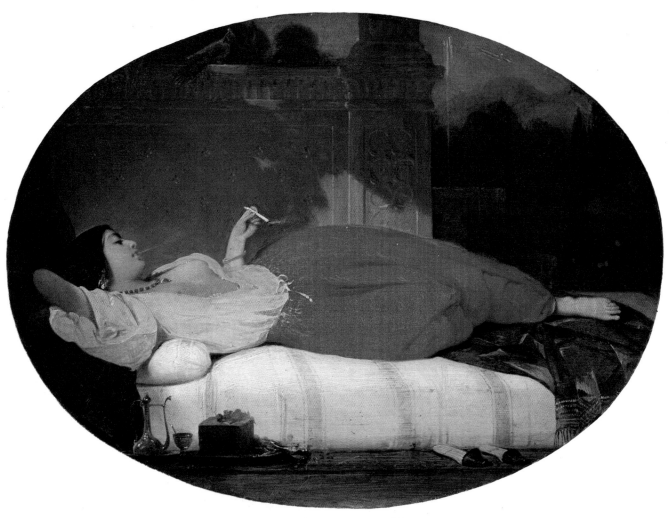

Jacques-Jean-Marie-Achille Devéria, 1800– 57 *Odalisque*
Oil on panel, oval 22.9 × 31.8cm

Jerome-Martin Langlois, 1779–1838 *Self-Portrait*
Oil on canvas 64.4 × 54.6cm

Louis Ducis, 1775– 1847 *Sappho Recalled to Life by the Charm of Music*
*c.*1811 Oil on canvas 116.2 × 146.7cm

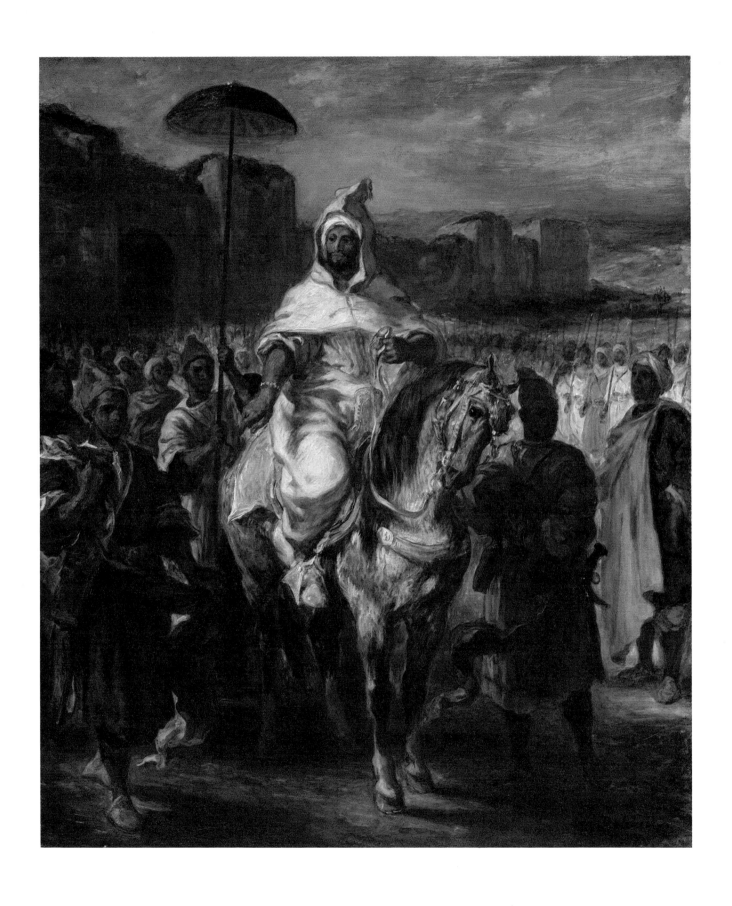

Eugène Delacroix, 1798–1863 *Abd Er Rahman, The Sultan of Morocco, Reviewing His Guard*
1856 Oil on canvas 64.8 × 54.6cm

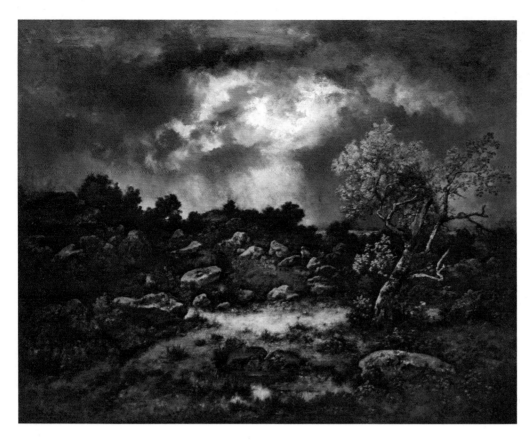

Narcisse Virgile Diaz de la Pena, 1801–76 *The Approaching Storm*
1870 Oil on canvas 83.8 × 106.7cm

Théodore Rousseau, 1812–67 *The Fisherman, Early Morning*
1853 Oil on canvas 95.9 × 132.1cm

Paul Guigou, 1834–71 *Landscape in Martigues*
Oil on canvas 27.9 × 46.4cm

Charles Emile Jacque, 1813–94 *Return to the Fold*
Oil on canvas 81.3 × 66cm

Henri Joseph Harpignies, 1819–1916 *A Farmhouse*
Oil on canvas 27.3 × 40cm

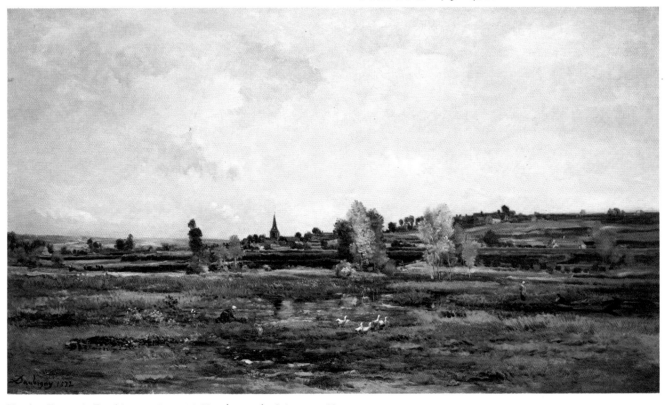

Charles François Daubigny, 1817–78 *Hamlet on the Seine near Vernon*
1872 Oil on canvas 85.1 × 146.1cm

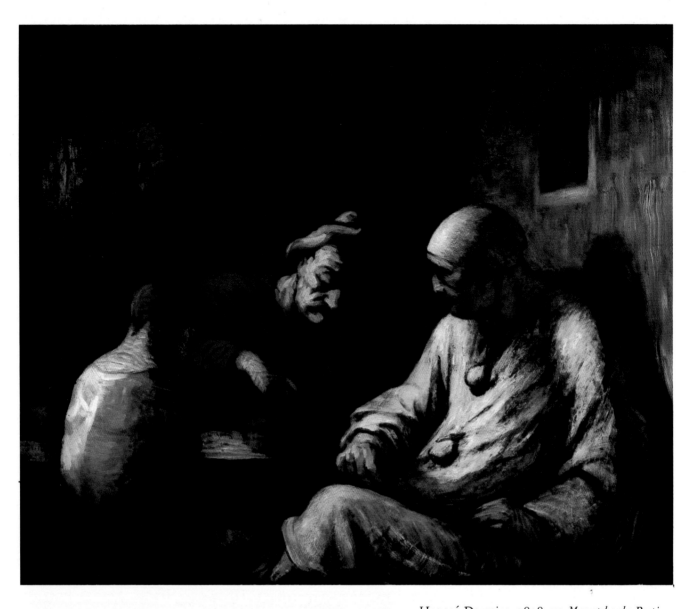

Honoré Daumier, 1808–79 *Mountebanks Resting*
1870 Oil on canvas 54.6 × 65.4cm

Honoré Daumier, 1808–79 *Study for Mountebanks Resting*
*c.*1865–6 Oil on cradled wood panel 29.2 × 36.8cm

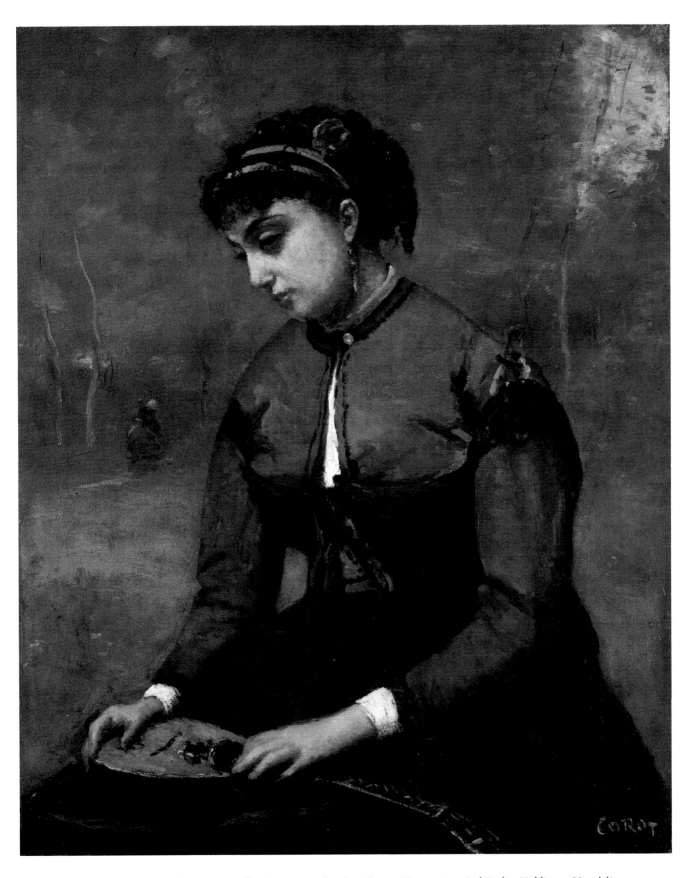

Jean-Baptiste Camille Corot, 1796–1875 *Young Woman in a Red Bodice Holding a Mandolin*
1868–70 Oil on cradled wood panel 46.4 × 36.8cm

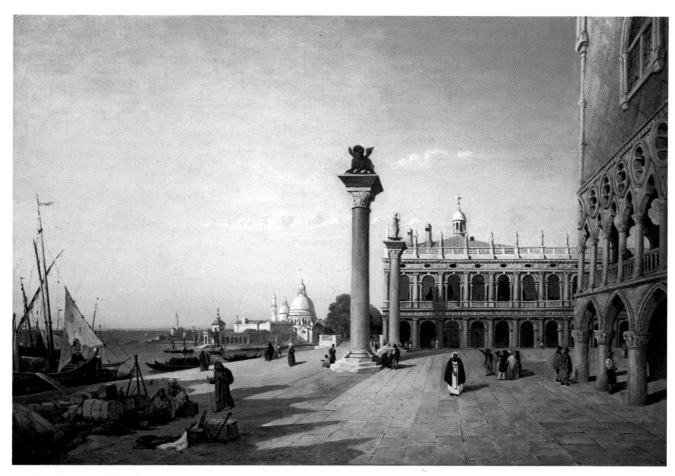

Jean-Baptiste Camille Corot, 1796–1875 *View of Venice, the Piazzetta, Seen from the Riva degli Schiavoni*
1834 Oil on canvas 47 × 68.6cm

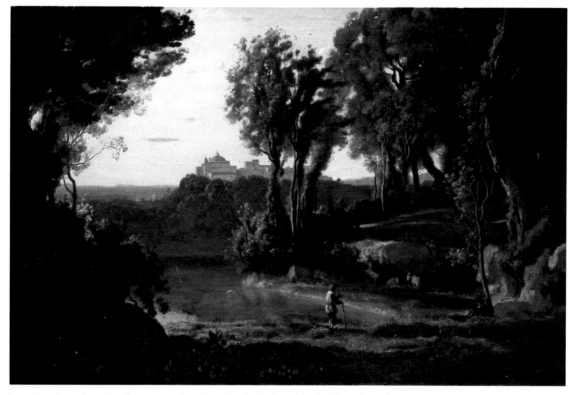

Jean-Baptiste Camille Corot, 1796–1875 *Site in Italy with the Church at Ariccia*
1839 Oil on canvas 53.3 × 81.3cm

92

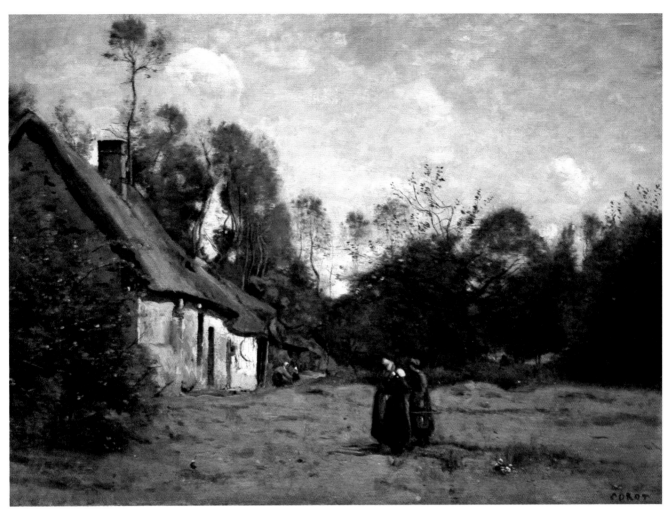

Jean-Baptiste Camille Corot, 1796–1875 *Farmhouse in Normandy*
*c.*1872 Oil on canvas 45.7 × 61cm

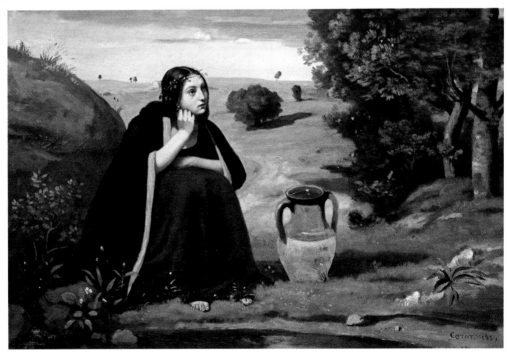

Jean-Baptiste Camille Corot, 1796–1875 *Rebecca at the Well*
1839 Oil on canvas 49.8 × 74cm

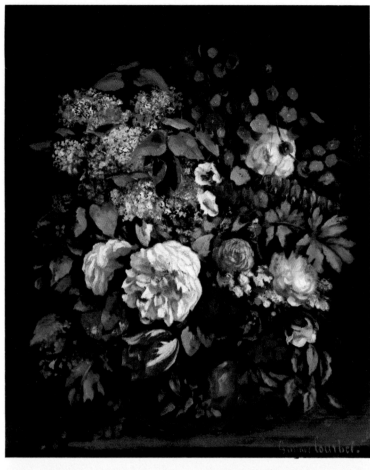

Gustave Courbet, 1819–77 *Vase of Mixed Flowers
(Lilacs, Roses, and Tulips)*
1863 Oil on canvas 64.8 × 54cm

Gustave Courbet, 1819–77 *Still Life: Apples, Pears,
and Primroses on a Table*
1871 Oil on canvas 59.7 × 73cm

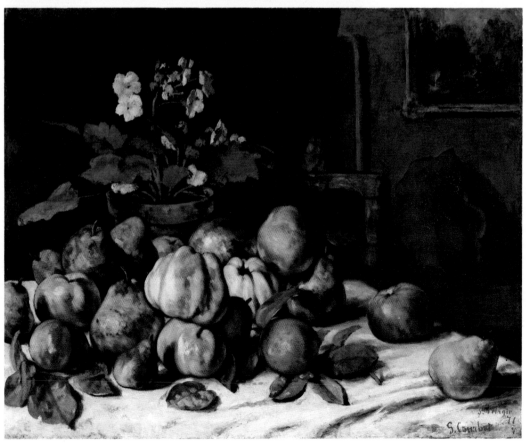

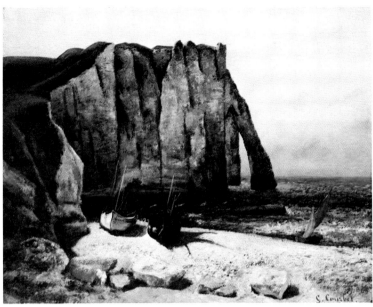

Gustave Courbet, 1819–77 *Cliffs at Etretat, La Porte d'Aval*
1869 Oil on canvas 65.4 × 81.3cm

Gustave Courbet, 1819–77 *Marine*
1866 Oil on canvas 50.2 × 61cm

Gustave Courbet, 1819–77 *The Stream of the Puits-Noir at Ornans*
1868 Oil on canvas 99.1 × 149.9cm

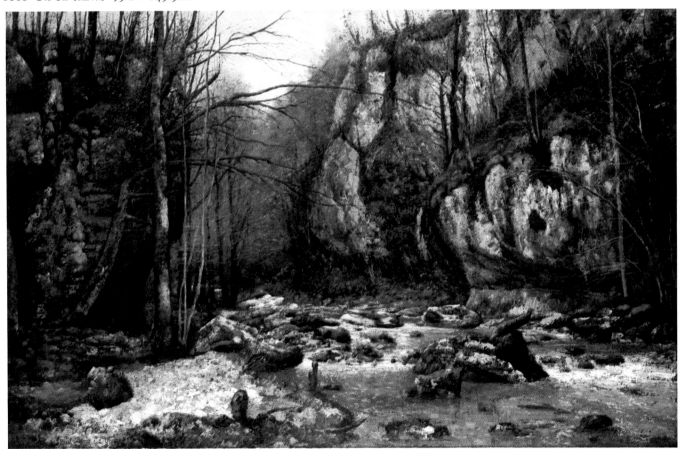

Stanislaus Victor Edouard Lepine, 1835–92
Figures in the Courtyard of a Château
Oil on canvas 44.5 × 31.8cm

Louis Eugène Boudin, 1824–98
The Beach at Trouville
1873 Oil on board 21 × 41.3cm

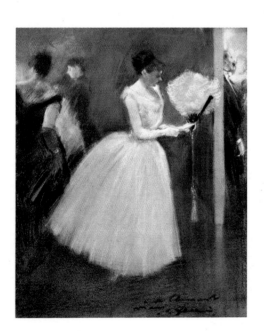

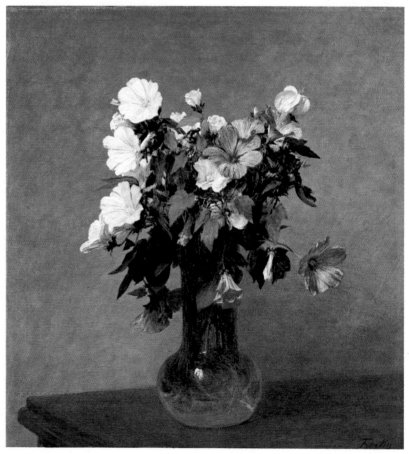

Jean-Louis Forain, 1852–1931 *Blonde Woman
with a Fan, Evening Party*
*c.*1884 Pastel on paper 54.8 × 45.7cm

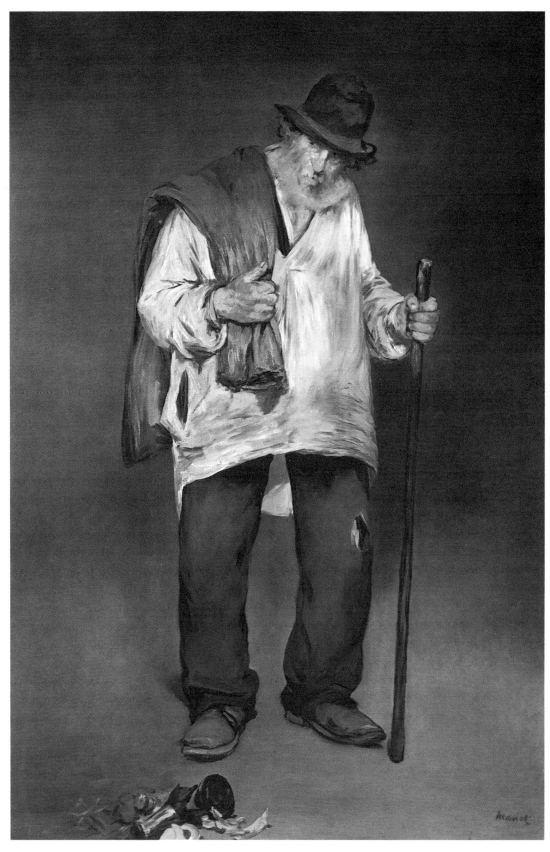

Edouard Manet, 1832–83
The Ragpicker
c.1869 Oil on canvas 194.9 × 130.2cm

Henri Fantin-Latour, 1836–1904 *White and Pink Mallows in a Vase*
1895 Oil on canvas 53.6 × 49.8cm

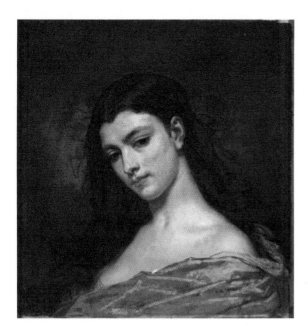

Thomas Couture, 1815–79 *Female Head*
*c.*1841 Oil on canvas 55.2 × 52.1cm

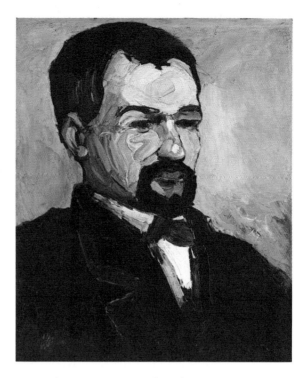

Paul Cézanne, 1839–1906 *Uncle Dominique*
*c.*1865–7 Oil on canvas 45.7 × 38.1cm

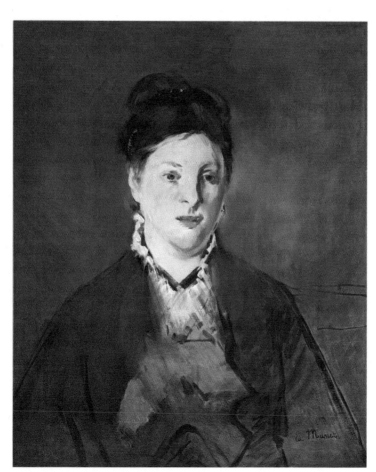

Edouard Manet, 1832–83 *Portrait of
Madame Manet*
1866 Oil on canvas 61 × 49.5cm

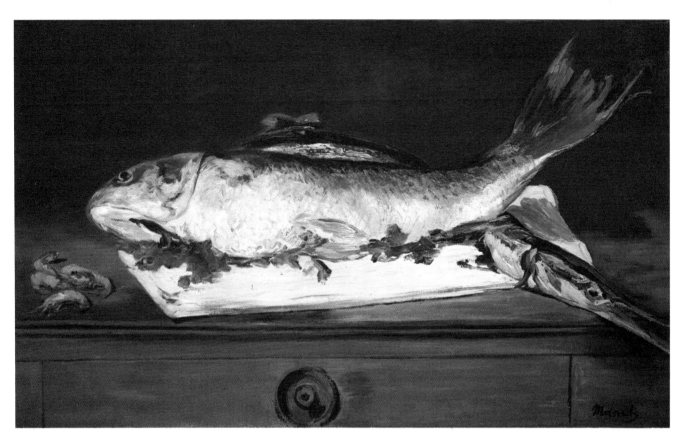

Edouard Manet, 1832–83 *Salmon, Pike, and Shrimp*
1864 Oil on canvas 44.5 × 71.8cm

Camille Jacob Pissarro, 1830–1903 *Pontoise, Banks of the Oise River*
1872 Oil on canvas 54 × 73cm

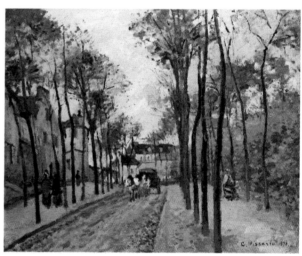

Camille Jacob Pissarro, 1830–1903
Le Boulevard des Fosses, Pontoise
1872 Oil on canvas 46.4 × 55.9cm

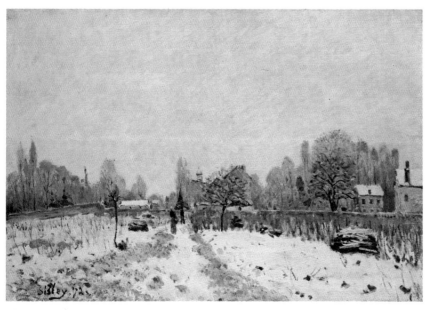

Alfred Sisley, 1839–99 *Louveciennes in the Snow*
1872 Oil on canvas 50.8 × 73.7cm

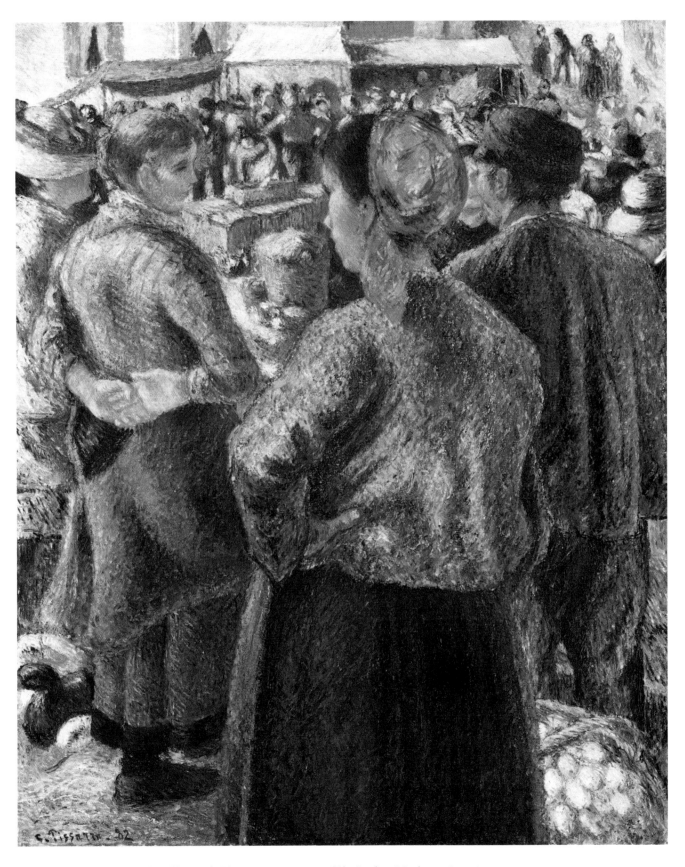

Camille Jacob Pissarro, 1830–1903 *The Poultry Market at Pontoise*
1882 Oil on canvas 80.8 × 65cm

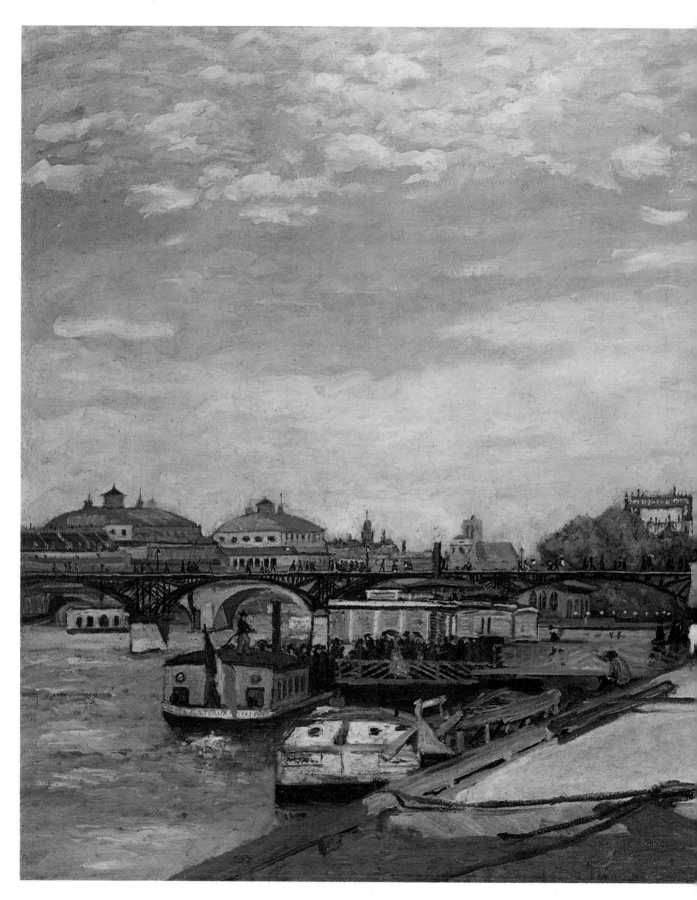

Pierre Auguste Renoir, 1841–1919 *Le Pont des Arts, Paris*
*c.*1868 Oil on canvas 61.6 × 102.9cm

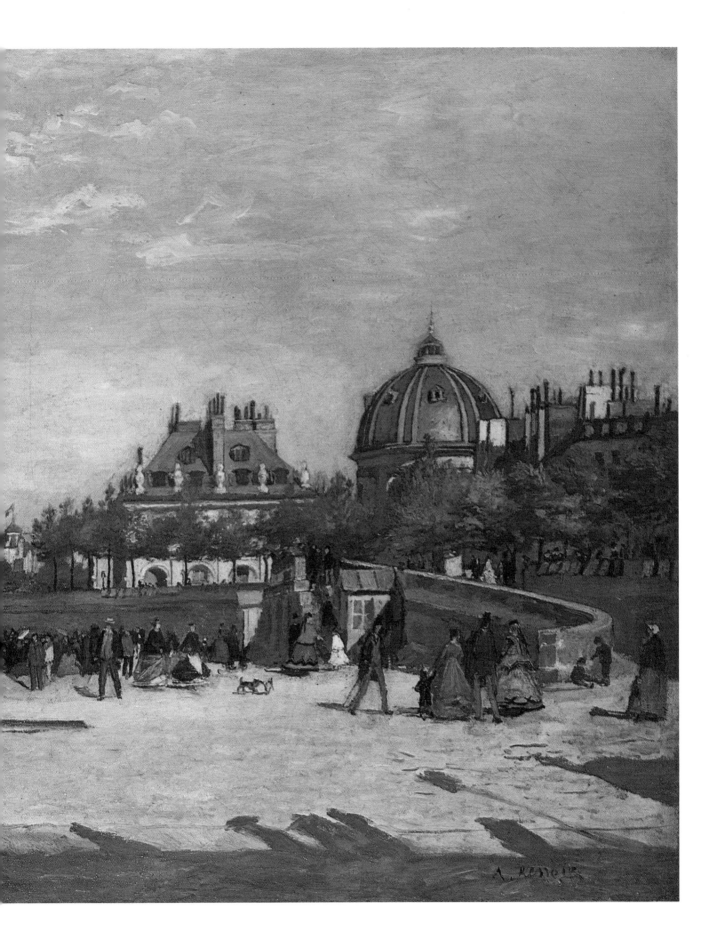

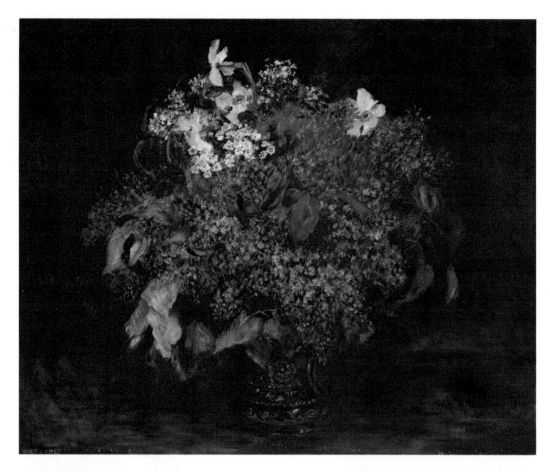

Pierre Auguste Renoir,
1841–1919 *Bouquet of
Lilacs*
1875 Oil on
canvas 54.6 × 65.4cm

Pierre Auguste Renoir,
1841–1919 *The Artist's
Studio, Rue
Saint-Georges*
1876 Oil on canvas
45.1 × 36.8cm

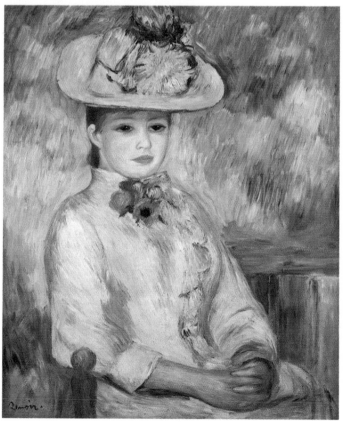

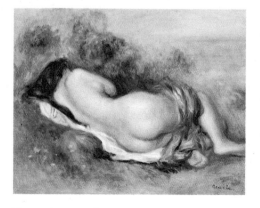

Pierre Auguste Renoir, 1841–1919
Reclining Nude
*c.*1890 Oil on canvas 33 × 40.6cm

Pierre Auguste Renoir, 1841–1919 *Girl in a Yellow
Hat* 1885 Oil on canvas 66.7 × 54.8cm

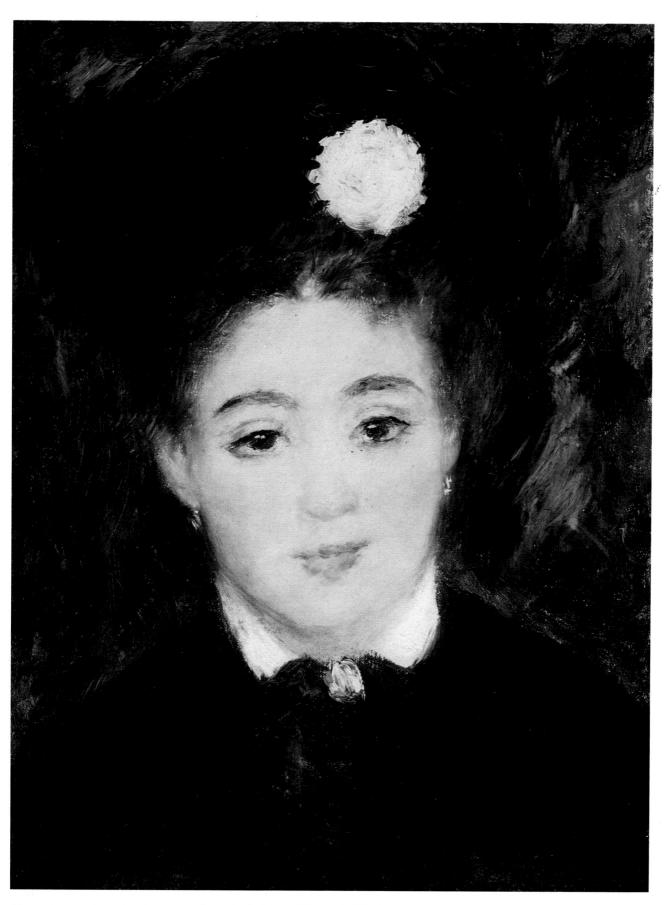

Pierre Auguste Renoir, 1841–1919 *Portrait of a Young Woman in Black*
*c.*1875–6 Oil on canvas 33.3 × 25cm

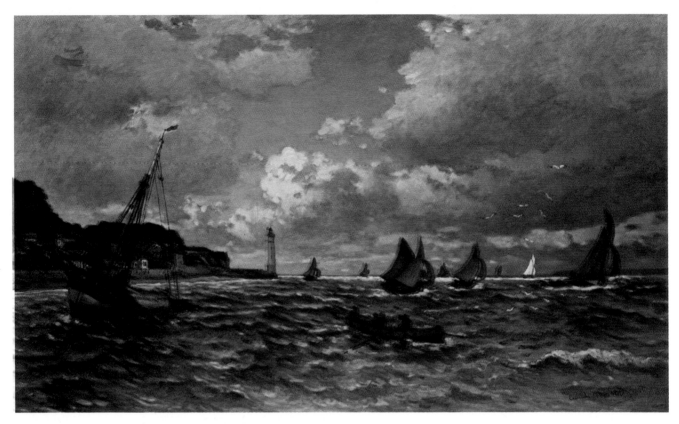

Claude Monet, 1840–1926 *Mouth of the Seine at Honfleur*
1865 Oil on canvas 90.2 × 149.9cm

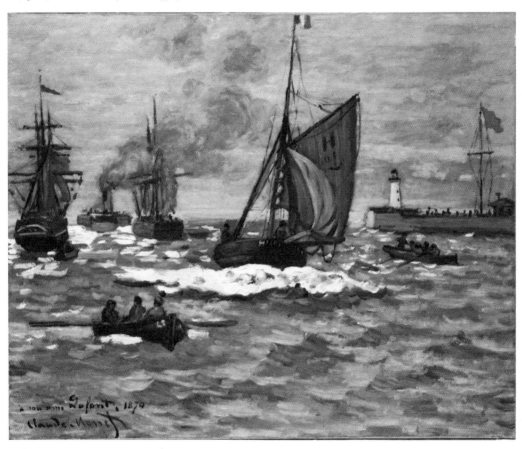

Claude Monet, 1840–1926 *Entrance to the Port of Honfleur*
1868 Oil on canvas 50.2 × 61cm

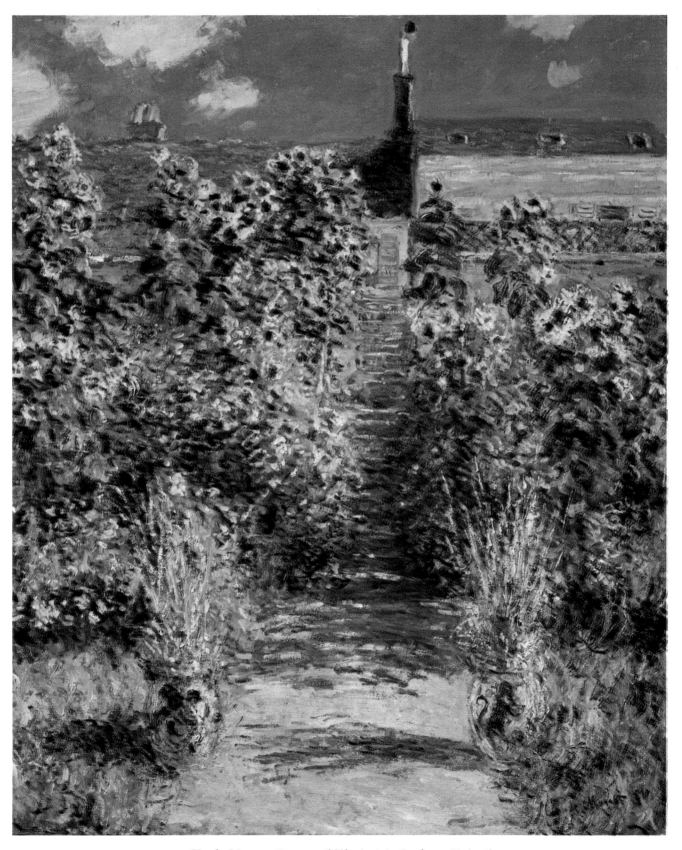

Claude Monet, 1840–1926 *The Artist's Garden at Vetheuil*
1881 Oil on canvas 100.3 × 81.3cm

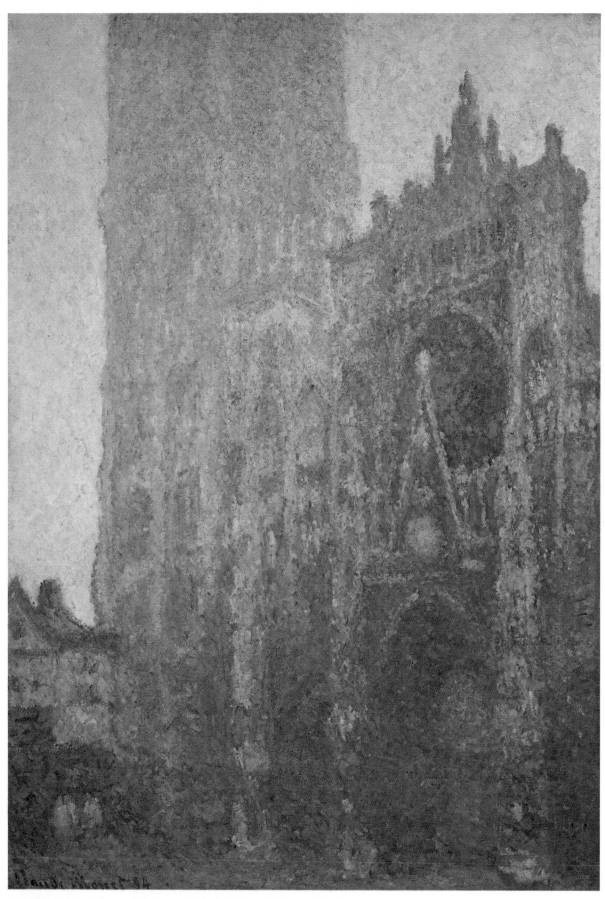

Claude Monet, 1840–1926 *Rouen Cathedral, Tour d'Albane, Morning*
1894 Oil on canvas 106 × 73.7cm

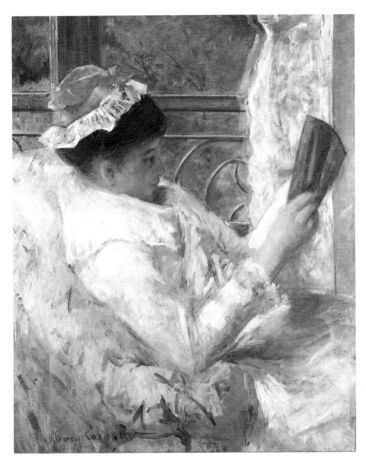

Mary Cassatt, 1845–1926 *Woman Reading (Lydia Cassatt)*
1878 Oil on canvas 78.7 × 62.9cm

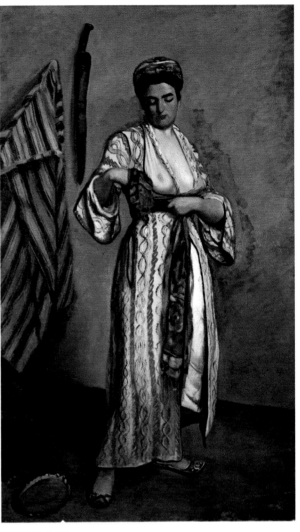

Jean-Frédéric Bazille, 1841–70 *Woman in Moorish Costume*
1869 Oil on canvas 100.3 × 59.7cm

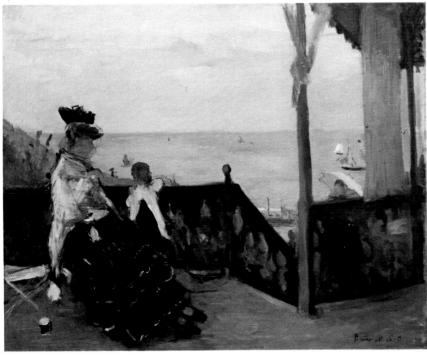

Berthe Morisot, 1841–95 *In a Villa at the Seaside*
1874 Oil on canvas 50.2 × 61.3cm

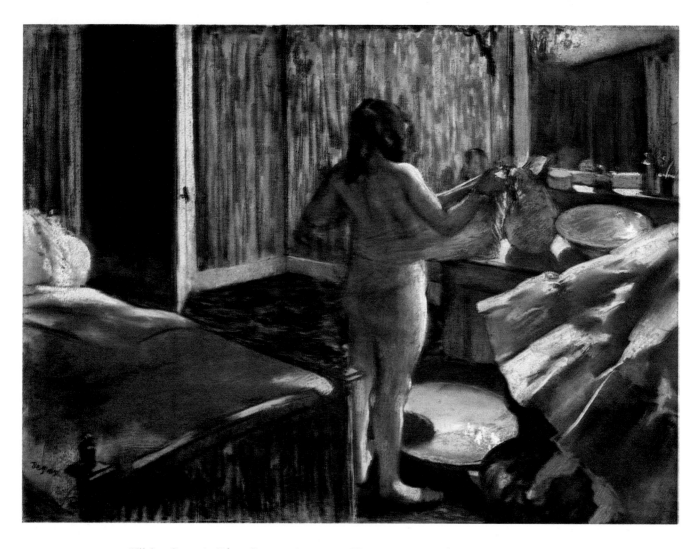

Hilaire-Germain-Edgar Degas, 1834–1917 *Woman at Her Toilet*
1886–90 Pastel over monotype 45.7 × 60.3cm

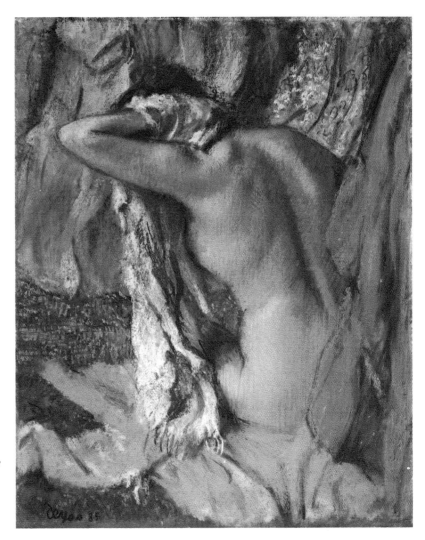

Hilaire-Germain-Edgar Degas, 1834–1917
After the Bath
1885 Pastel on paper mounted to
cardboard 66 × 52.7cm

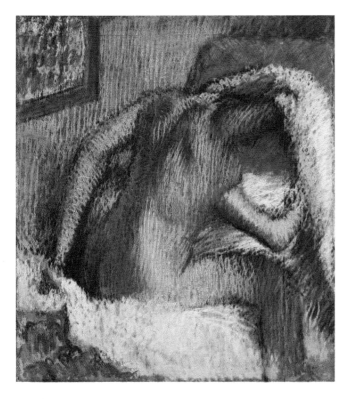

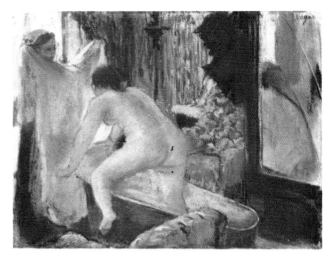

Hilaire-Germain-Edgar Degas, 1834–1917 *Woman Getting out of the Bath*
*c.*1877 Pastel over monotype on laid paper 15.9 × 21.6cm

Hilaire-Germain-Edgar Degas, 1834–1917 *Woman Drying Her Hair*
*c.*1905–7 Pastel on paper 71.1 × 62.2cm

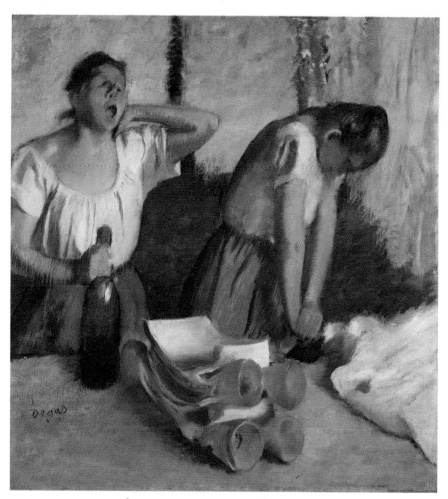

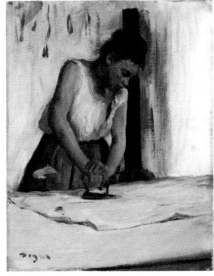

Hilaire-Germain-Edgar Degas, 1834–1917 *The Ironers*
*c.*1884 Oil on canvas 81.9 × 74.9cm

Hilaire-Germain-Edgar Degas,
1834–1917 *The Ironer*
1873 Oil on canvas 24.85 × 19.15cm

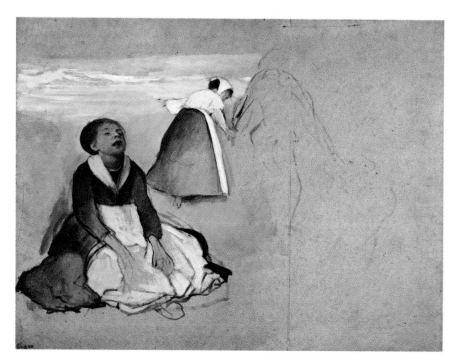

Hilaire-Germain-Edgar Degas, 1834–1917 *Nurses on the Beach*
*c.*1875 Oil on paper mounted on canvas 44.5 × 60.3cm

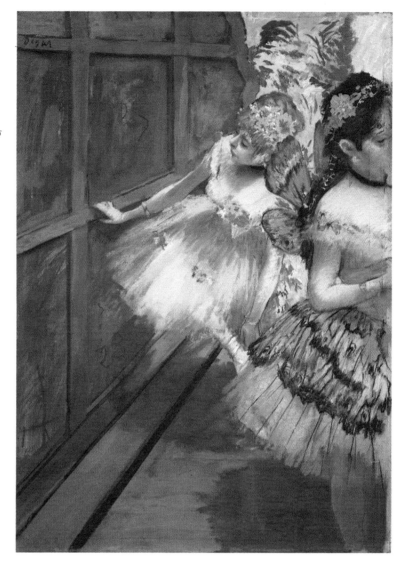

Hilaire-Germain-Edgar Degas,
1834–1917 *Dancers in the Wings*
*c.*1880 Pastel and tempera on
paper 66.7 × 47.2cm

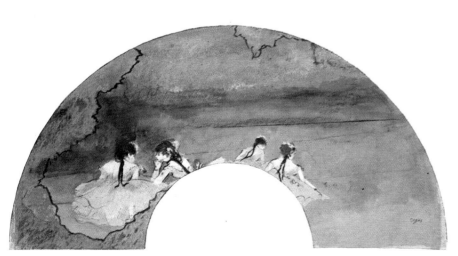

Hilaire-Germain-Edgar Degas, 1834–1917 *Dancers on the Stage*
*c.*1879 Pastel on paper, fan drawing 35.6 × 61.3cm

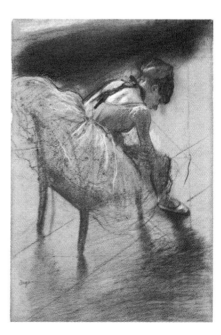

Hilaire-Germain-Edgar Degas,
1834–1917 *Dancer Fixing Her Shoe*
*c.*1885 Charcoal and white pastel on
grey paper 43.2 × 29.4cm

113

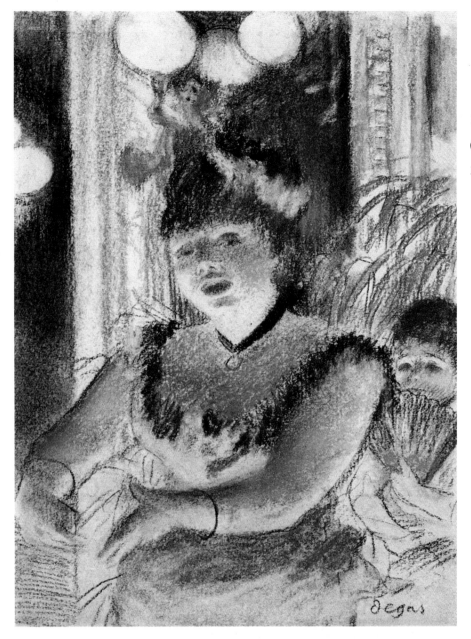

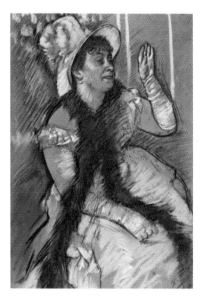

Hilaire-Germain-Edgar Degas,
1834–1917 *Cafe-Concert Singer
(probably Mlle. Dumay)*
1879 Pastel on
paper 16.1 × 11.7cm

Hilaire-Germain-Edgar Degas,
1834–1917 *Madame Dietz-Monin*
1879 Pastel on brown
paper 47 × 31.8cm

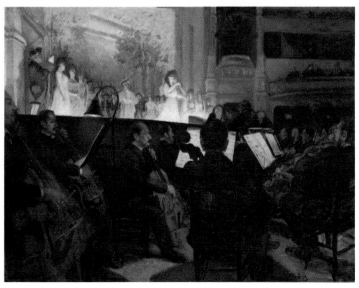

Raoul Dufy, 1877–1953 *The
Orchestra, Théâtre du Havre*
1902 Oil on canvas 113 × 146.1cm

Henri de Toulouse-Lautrec, 1864–1901 *Red-Headed Woman in the Garden of Monsieur Forest*
1889 Oil on cardboard 71.1 × 58.4cm

Henri de Toulouse-Lautrec, 1864–1901 *Profile of a Prostitute*
1893 Oil on cardboard 61.6 × 48.3cm

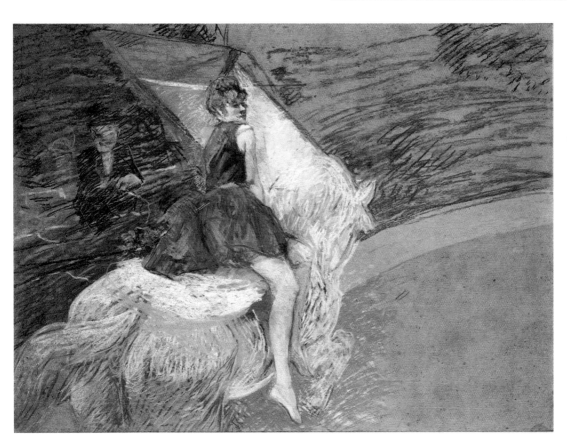

Henri de Toulouse-Lautrec, 1864–1901 *At the Circus Fernando, Rider on a White Horse*
1888 Pastel and gouache on board 59.9 × 79.4cm

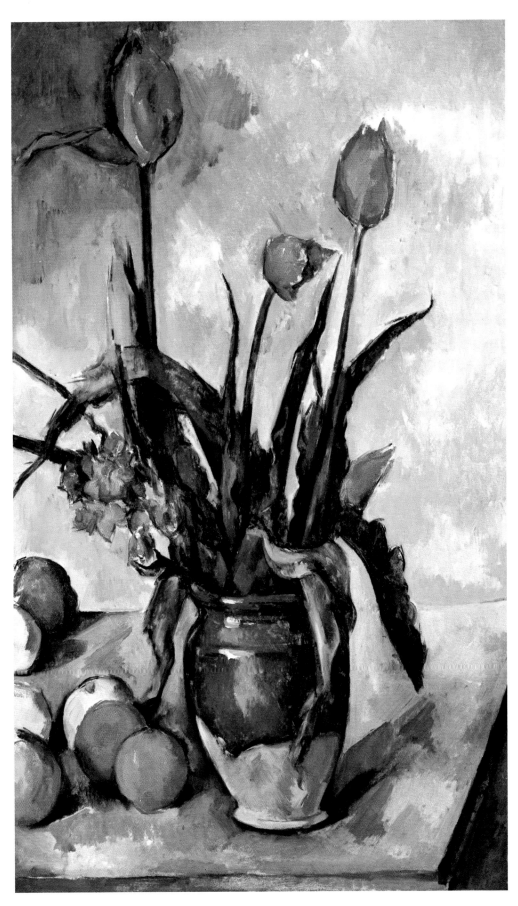

Paul Cézanne, 1839–1906 *Tulips in a Vase*
c. 1890–2 Oil on paper mounted on board 72.4 × 42.1cm

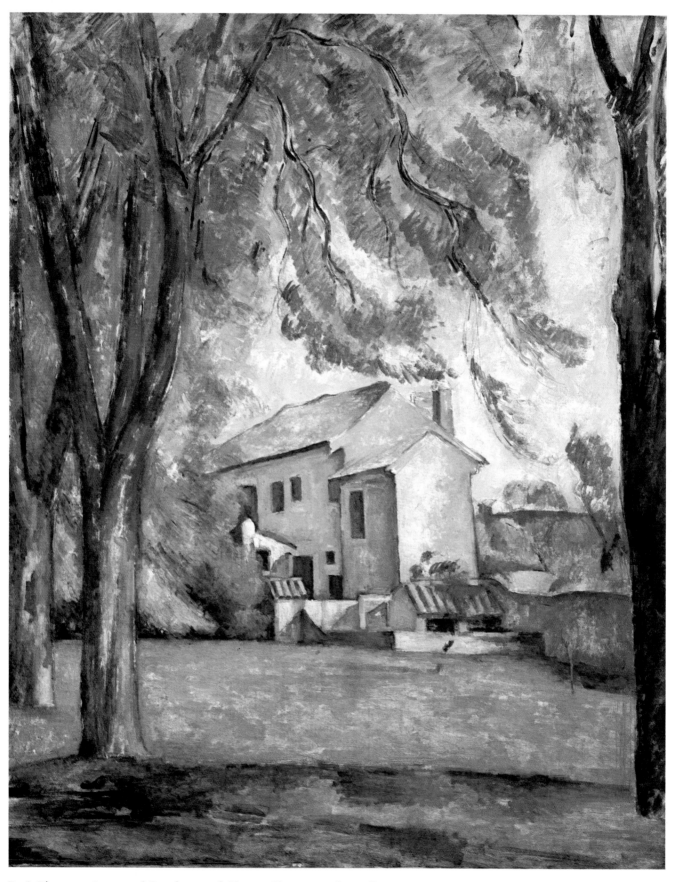

Paul Cézanne, 1839–1906 *Farmhouse and Chestnut Trees at Jas-de-Bouffan*
*c.*1885 Oil on canvas 91.4 × 73.7cm

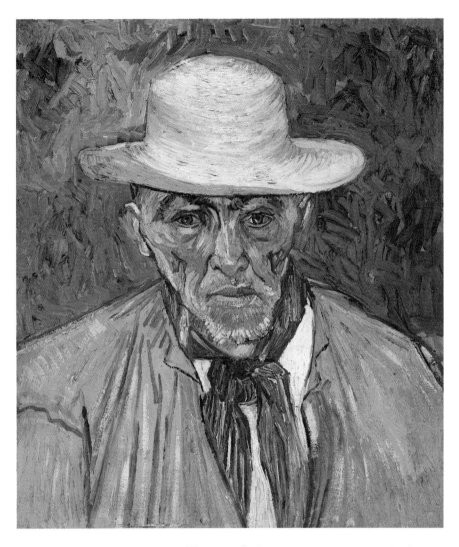

Vincent van Gogh, 1853–90 *Portrait of a Peasant (Patience Escalier)*
August 1888 Oil on canvas 64.4 × 54.6cm

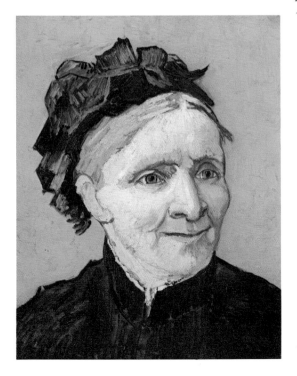

Vincent van Gogh, 1853–90 *Portrait of the Artist's Mother*
October 1888 Oil on canvas 39.4 × 31.1cm

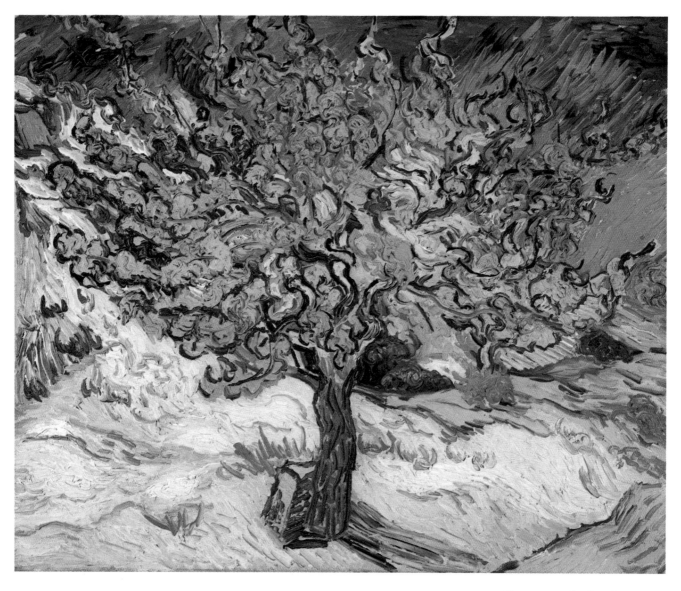

Vincent van Gogh, 1853–90
The Mulberry Tree
1889 Oil on canvas 54 × 65cm

Paul Gauguin, 1848–1903
Tahitian Woman and Boy
1899 94.6 × 61.6cm

Vincent van Gogh, 1853–90
Winter (A Cemetery)
1885 Oil on canvas on
panel 59.1 × 78.1cm

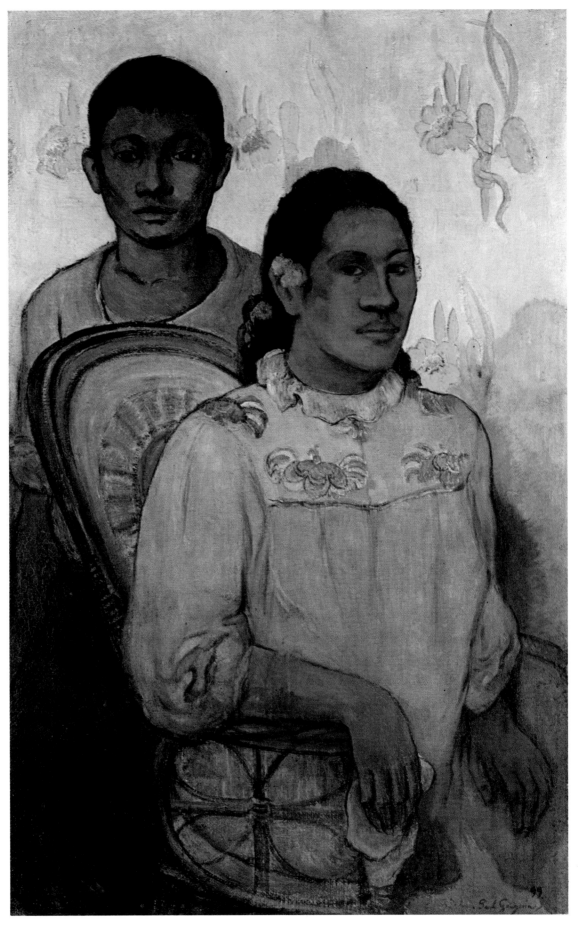

Emile Bernard, 1868–1941 *Brittany Landscape*
1887 Oil on canvas 73.7 × 100.3cm

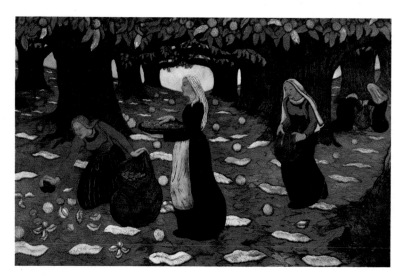

Georges Lacombe, 1868–1916 *The Chestnut Gatherers*
1892 Oil on canvas 152.7 × 236.2cm

Paul Serusier, 1863–1927 *Still Life with Violets*
1891 Oil on canvas 38.1 × 46.4cm

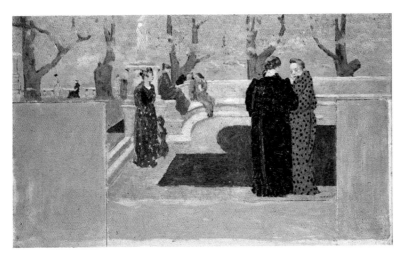

Ker-Xavier Roussel, 1867–1944 *Réunion des Dames*
1894 Oil on canvas 45.7 × 74.9cm

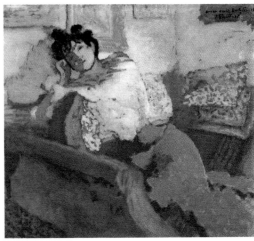

Edouard Vuillard, 1868–1940 *Portrait of Madame Hessel*
*c.*1900 Oil on board 43.2 × 45.7cm

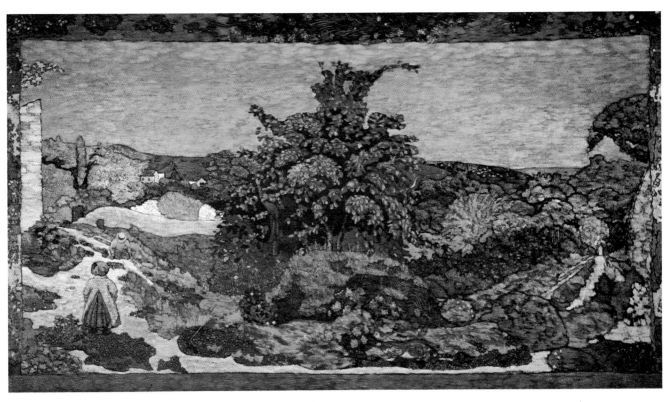

Edouard Vuillard, 1868–1940 *The First Fruits*
1899 Oil on canvas 243.8 × 431.8cm

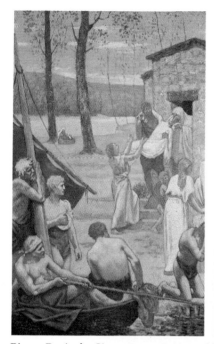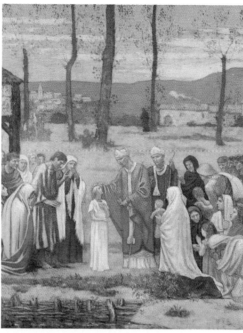

Pierre Puvis de Chavannes, 1824–98 *The Meeting of St. Genevieve and St. Germain*
1879 Oil on canvas (triptych) Panel A: 134.6 × 81.9cm; Panel B: 134.6 × 89.5cm; Panel C: 134 × 81.3cm

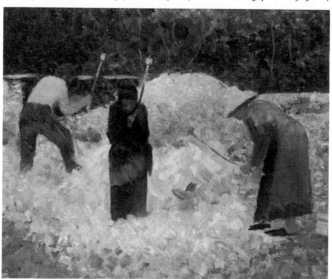

Georges Pierre Seurat, 1859–91
The Stone Breakers, Le Raincy
*c.*1882 Oil on canvas 36.2 × 45.1cm

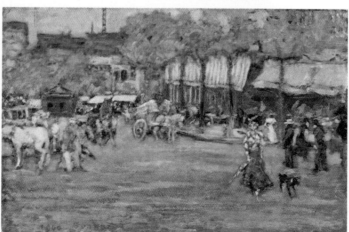

Pierre Bonnard, 1867–1947 *La Place Clichy, Paris*
1900 Oil on cardboard (triptych) Left panel: 34.9 × 24.1cm; Centre: 33.9 × 52.7cm; Right panel: 34.5 × 22.4cm

The Twentieth Century

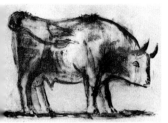

The Impressionists and Post-Impressionists had reacted against the academic realism of the nineteenth century. The new generation of artists in the early years of the twentieth century continued both the liberation of colour begun by the Impressionists and the interest in tight structure shown by the Post-Impressionists. The first change appeared in the fierce, jarring colours of paintings by Matisse, Braque and Vlaminck of 1905–06. A few years later Picasso and Braque invented the style of Cubism. Initially banishing all colours but brown, white and black, they created paintings in which multiple views of a subject were shown simultaneously. Later they re-introduced colour and simplified their compositions.

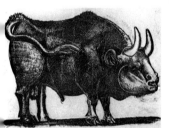

At the same time as French painters were exploring new approaches, German and Russian artists were also innovative. For example, Kandinsky, after a period of expressive freedom in his use of colour, was the first painter to plunge into non-objective painting. Klee, on the other hand, was inspired by the directness of children's art and painted his seemingly naïve but actually highly sophisticated and complex works of art.

A number of masterpieces of French twentieth-century art are on display in the Museum, including Modigliani's elegant *Portrait of Jeanne Hebuterne* and Braque's impressive *Artist and Model*. One can study the radiant colour of Matisse's sensuous paintings in four fine examples, from the languorous nude wrapped in a black lace shawl of 1918 to the compact *Odalisque with Striped Dress* of 1937.

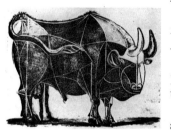

It is Picasso, however, who dominated the painting of this century. *Nude Combing Her Hair* shows the incorporation of African sculpture into his work; *La Pointe de la Cité* is one of the high-points of Cubism; and *Bust of a Woman* shows his return to classical antiquity for inspiration. With its contrast between the roundness of the animal's head and the jagged forms of the marine life, *The Ram's Head* is one of his most powerful still lifes. *Woman with Book* of 1932, with its brilliant colours locked into a web of black lines, is one of the most arresting paintings in the Museum. Perhaps nothing teaches us more about Picasso's art than his 'progressive suites' of lithographs, in which we can see him constantly simplifying his images. Indeed, he once said, 'a picture used to be a sum of additions. In my case a picture is a sum of destructions.'

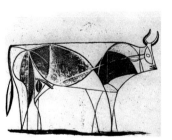

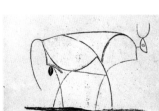

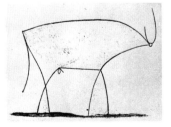

Pablo Ruiz y Picasso, 1881–1973 *The Bull* December 1945–January 1946 Lithograph. From top: 1st state, 32.4 × 44.5cm; 2nd state, 33 × 44.5cm; 4th state, 33 × 44.5cm; 8th state, 33 × 44.5cm; 10th state, 33 × 56.2cm; 11th state, 33 × 44.5cm. All states: 1 of 18 artist's proofs

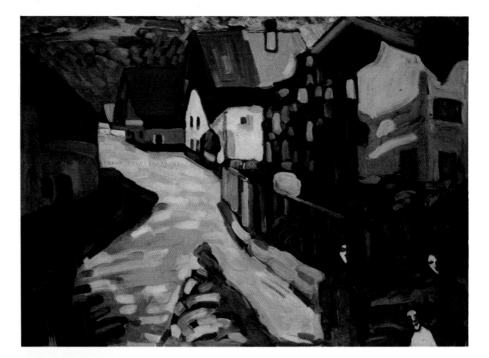

Wassily Kandinsky, 1866–1944
Street in Murnau with Women
1908 Oil on board 71.1 × 97.8cm

Maurice Vlaminck, 1876–1958
Still Life with Lemons
1907 Oil on board 50.2 × 64.1cm

Georges Rouault, 1871–1958 *Two Nudes*
(The Sirens)
1906–8 Gouache on paper 68.6 × 54.6cm

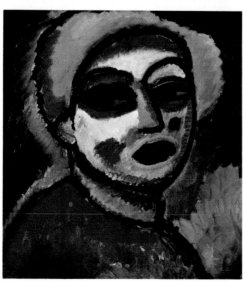

Alexej von Jawlensky,
1867–1941 *Blonde*
1911 Oil on cardboard
53.3 × 49.2cm

126

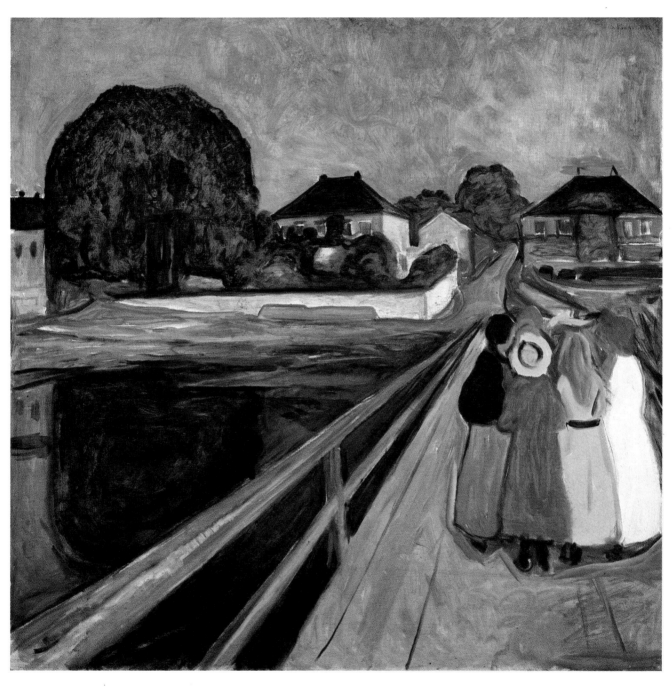

Edvard Munch, 1863–1944 *Girls on a Bridge*
1902 Oil on canvas 101 × 102.2cm

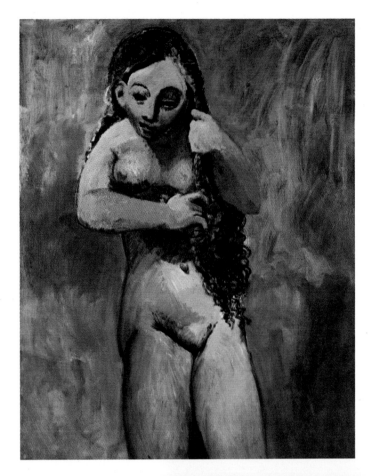

Pablo Ruiz y Picasso, 1881–1973
Nude Combing Her Hair
1906 Oil on canvas 104.1 × 80cm

Pablo Ruiz y Picasso, 1881–1973
Bust of a Woman
1923 Oil with fixed black chalk on
canvas 99.7 × 81.3cm

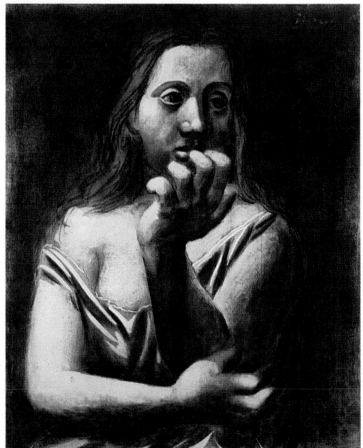

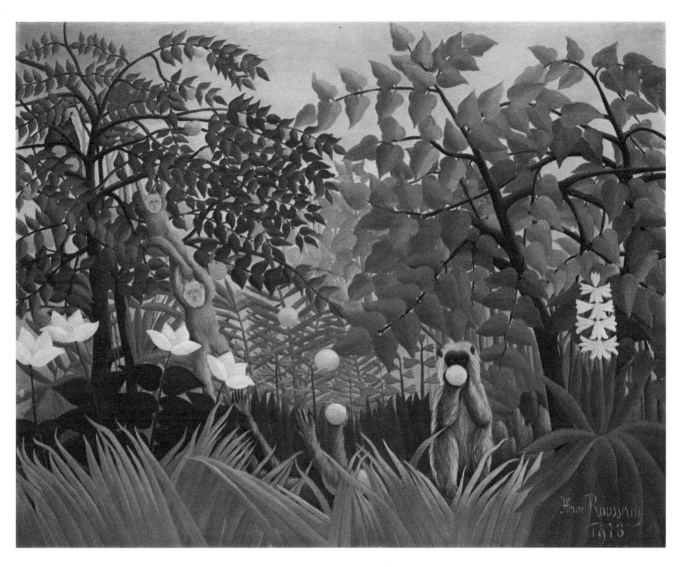

Henri Rousseau, 1844–1910 *Exotic Landscape*
1910 Oil on canvas 130.2 × 162.6cm

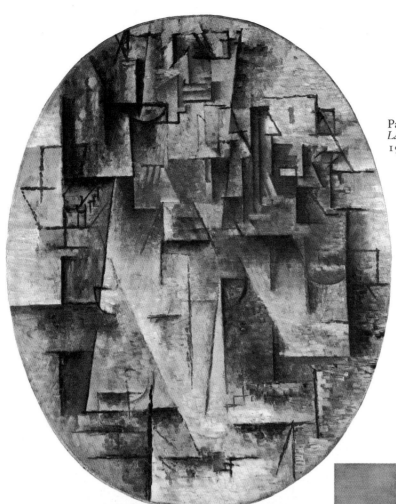

Pablo Ruiz y Picasso, 1881–1973
La Pointe de la Cité
1912 Oil on canvas 90.2 × 71.1cm

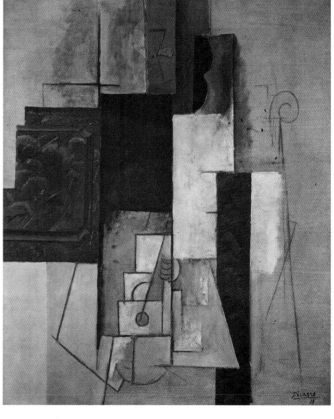

Lyonel Feininger, 1871–1956 *Street: Near the Palace*
1915 Oil on canvas 100.3 × 80cm

Pablo Ruiz y Picasso, 1881–1973 *Woman with a Guitar*
1913 Oil on canvas 100 × 81.3cm

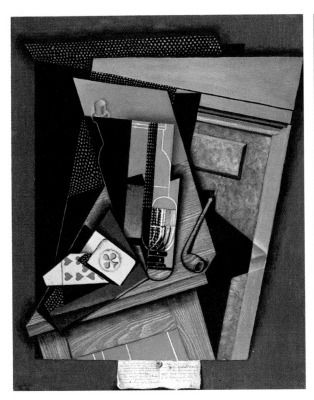

Juan Gris, 1887–1927 *Still Life with a Poem*
1915 Oil and collage on canvas 80.6 × 64.8cm

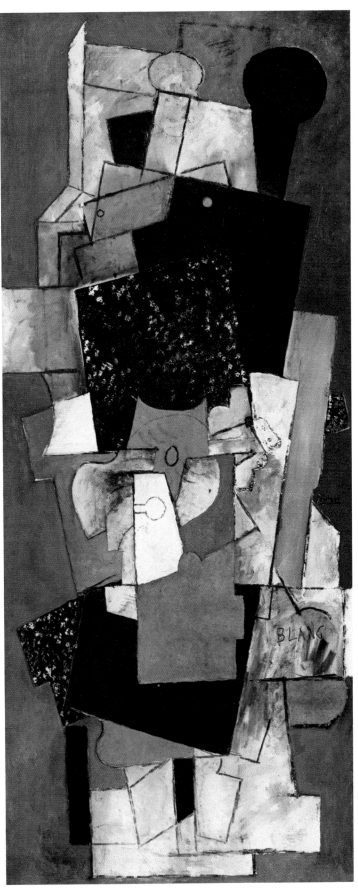

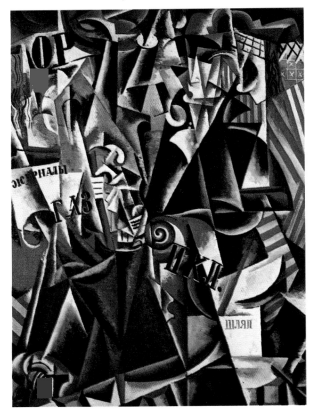

Liubov Popova, 1889–1924 *The Traveller*
1915 Oil on canvas 142.2 × 105.4cm

Pablo Ruiz y Picasso, 1881–1973
Woman with a Guitar
1915 Oil on canvas 184.8 × 74.9cm

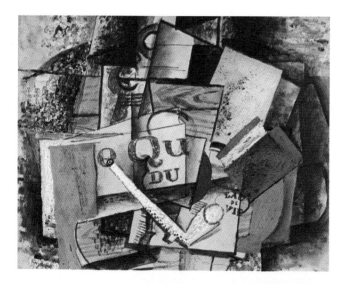

Georges Braque, 1882–1963 *Still Life with Pipe*
1912 Oil on canvas 33.7 × 42.1cm

Georges Braque, 1882–1963 *La Musique*
1918 Oil on canvas 64.8 × 92.1cm

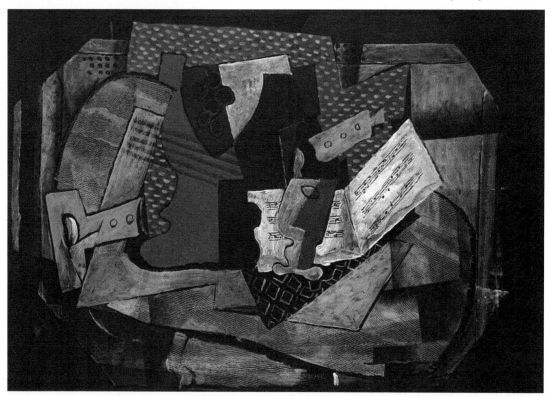

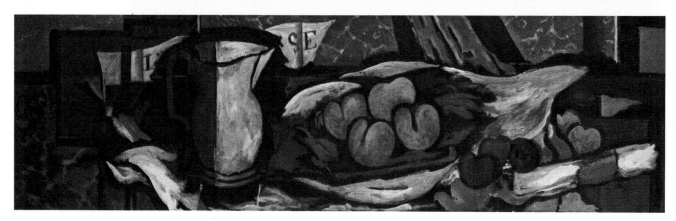

Georges Braque, 1882–1963 *Pitcher, Score, Fruits, and Napkin*
1926 Oil and sand on canvas 36.2 × 120.7cm

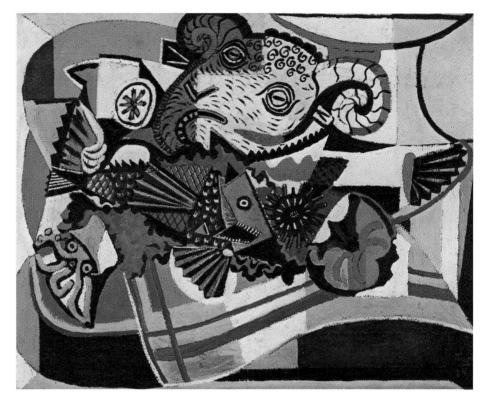

Pablo Ruiz y Picasso, 1881–1973
The Ram's Head
1925 Oil on canvas
80 × 99.1cm

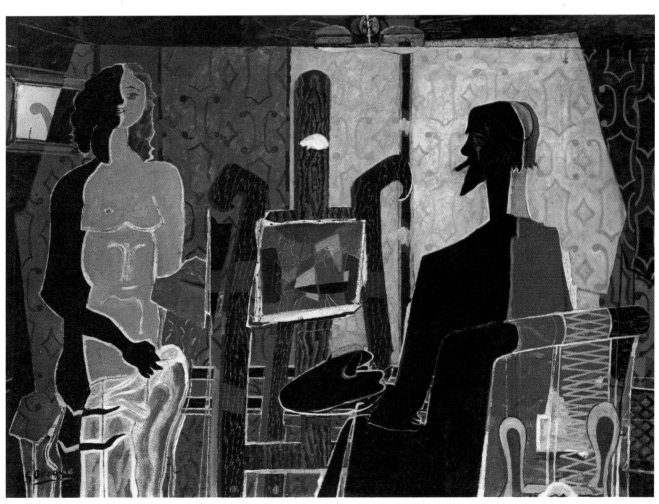

Georges Braque, 1882–1963 *Artist and Model* 1939 Oil on canvas 129.8 × 180.2cm

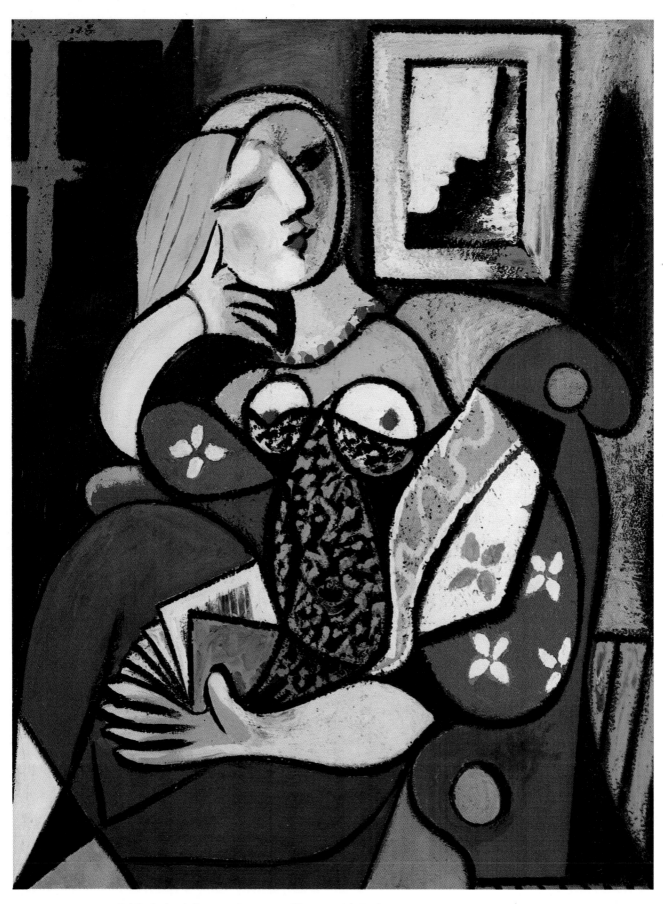

Pablo Ruiz y Picasso, 1881–1973 *Woman with Book*
1932 Oil on canvas 129.5 × 96.5cm

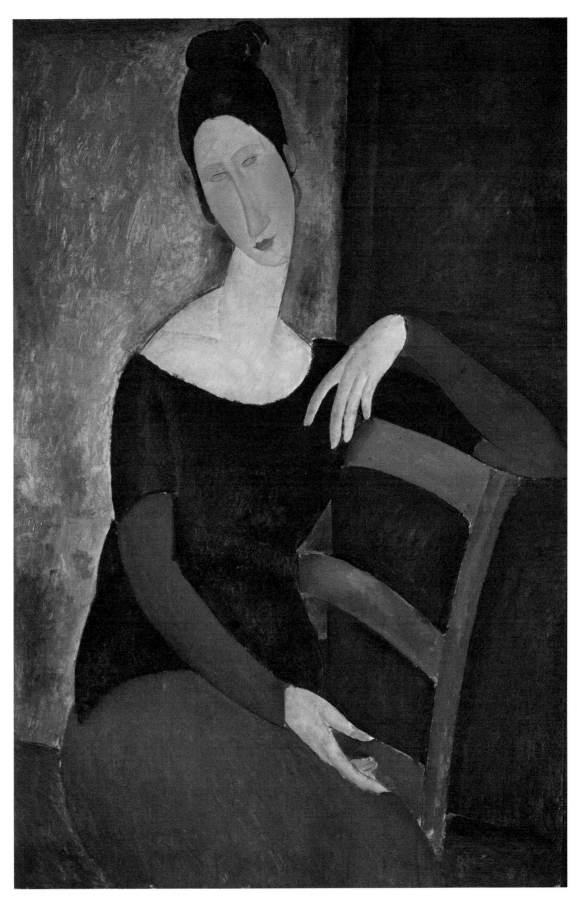

Amedeo Modigliani, 1884–1920 *Portrait of Jeanne Hebuterne*
1918 Oil on canvas 100.3 × 65.4cm

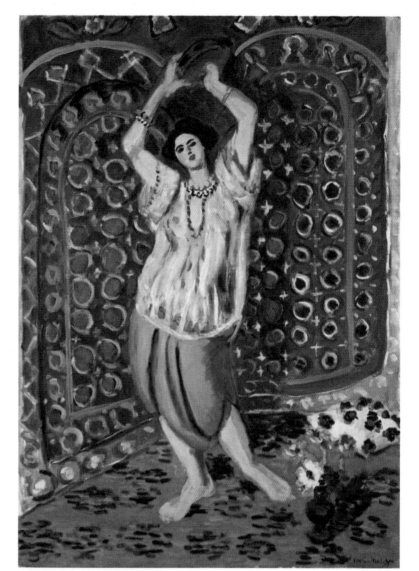

Henri Matisse, 1869–1954 *Odalisque with
Tambourine (Harmony in Blue)*
1926 Oil on canvas 91.4 × 64.8cm

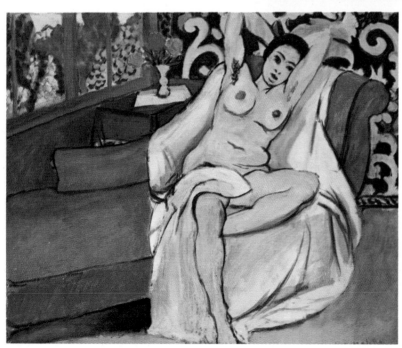

Henri Matisse, 1869–1954 *Nude on a Sofa*
1923 Oil on canvas 50.8 × 61cm

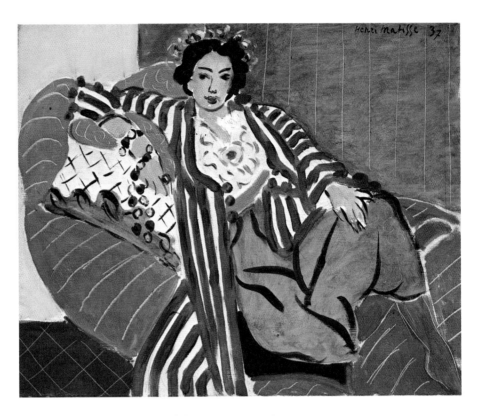

Henri Matisse, 1869–1954 *Odalisque with Striped Dress*
1937 Oil on canvas 38.1 × 45.7cm

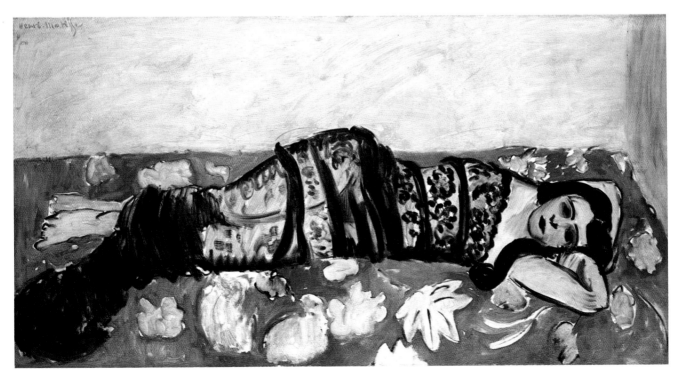

Henri Matisse, 1869–1954 *The Black Shawl (Lorette VII)*
1918 Oil on canvas 67.3 × 129.5cm

Emil Nolde, 1867–1956 *The Sea I*
1912 Oil on canvas 73.7 × 88.9cm

Maurice Utrillo, 1883–1955 *Place du Tertre à Montmartre*
*c.*1911 Oil on canvas 53.3 × 72.4cm

Chaim Soutine, 1894–1943 *Landscape at Cagnes*
1923–4 Oil on canvas 54.6 × 65.4cm

Franz Marc, 1880–1916 *Bathing Girls*
*c.*1910 Oil on canvas 138.4 × 196.9cm

Oskar Kokoschka, 1886–1980 *Portrait of Frau Erfurth*
1921 Oil on canvas 94.9 × 64.4cm

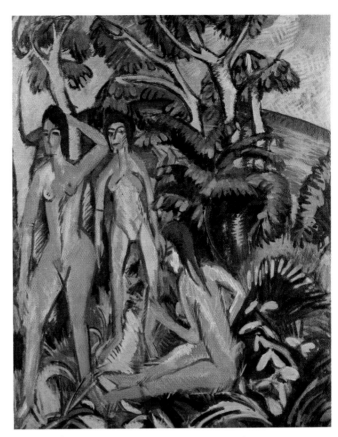

Ernst Ludwig Kirchner, 1880–1938 *Bathers beneath Trees,*
Fehmarn 1913 Oil on canvas 150.5 × 120cm

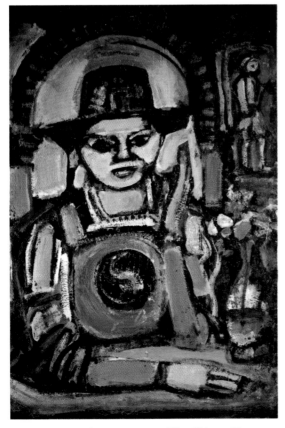

Georges Rouault, 1871–1958 *The Chinese Man*
1937 Oil on paper mounted on canvas 104.1 × 72.4cm

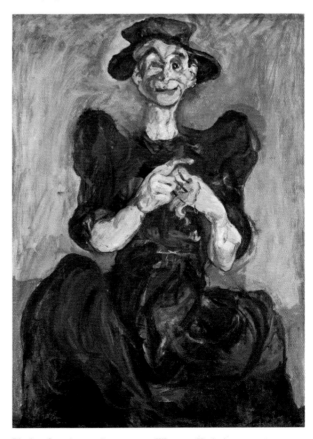

Chaim Soutine, 1894–1943 *Woman Knitting*
*c.*1924–5 Oil on canvas 82.6 × 59.7cm

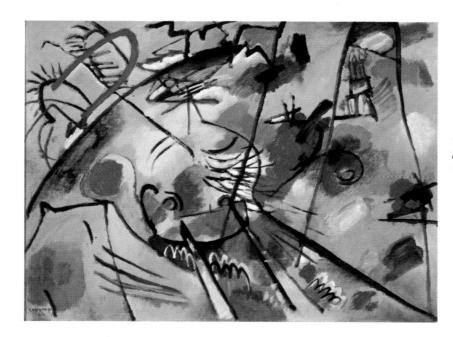

Wassily Kandinsky, 1866–1944
Improvisation 24 (Troika Number 2)
1912 Oil on board 48.6 × 65cm

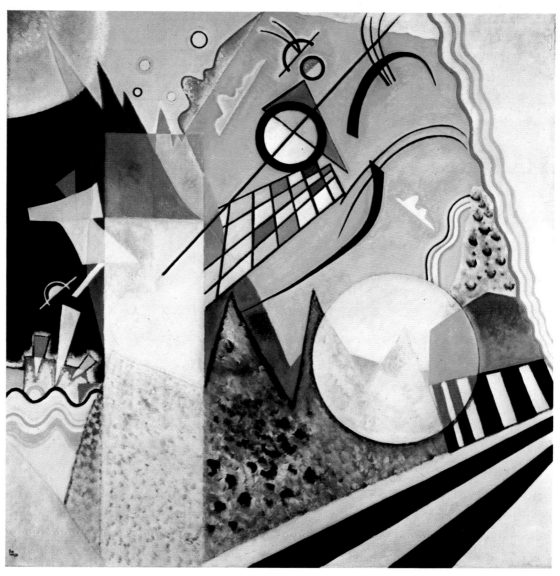

Wassily Kandinsky, 1866–1944 *Open Green*
1923 Oil on canvas 97.2 × 97.2cm

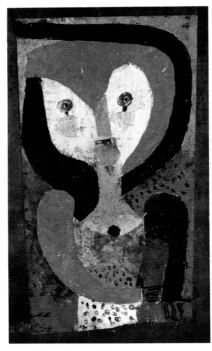

Paul Klee, 1879–1940 *Maid of Saxony*
1922 Oil on oil-primed muslin
mounted on gold foil, mounted on
painted board Composition:
36.2 × 21.8cm; Board Mount:
38.4 × 23.8cm

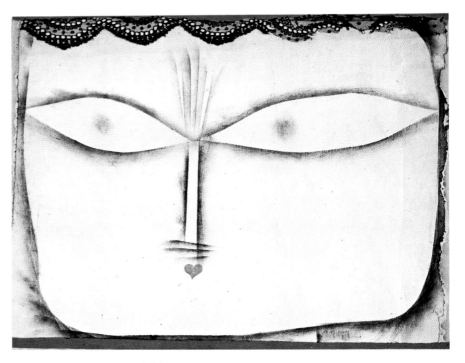

Paul Klee, 1879–1940 *Idol for Housecats*
1924 Oil transfer, watercolour, and lace collage on chalk-primed muslin,
mounted on painted board Composition: 35.1 × 46.6cm; Mount: 39 × 50.2cm

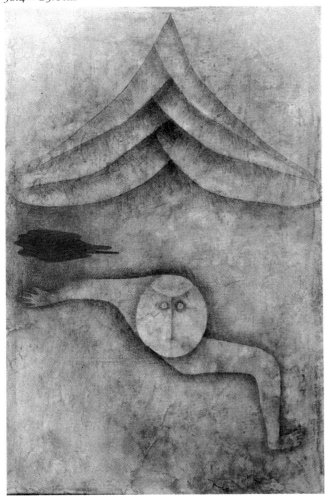

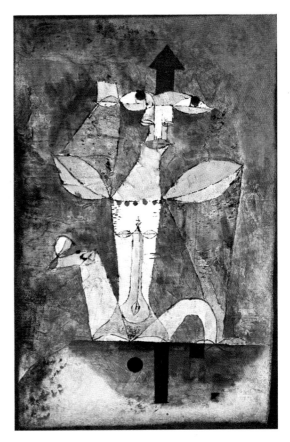

Paul Klee, 1879–1940
Barbarians' Venus
1921 Oil, oil transfer, and opaque watercolour
on plaster-coated gauze on painted board
Composition: 40.9×26.7cm
Mount: 45.1×30.5cm

Paul Klee, 1879–1940 *Refuge*
1930 Oil, opaque and transparent watercolour on
plaster-coated gauze, on paper-faced board, in wood
frame 54.2 × 35.1cm

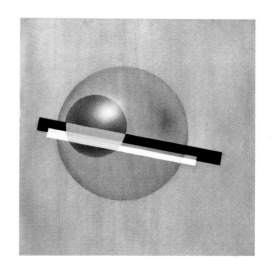

Laszlo Moholy-Nagy, 1895–1946 *AL 3*
1926 Oil, watercolour, and shellac on sheet
aluminium 40.2 × 40.2cm

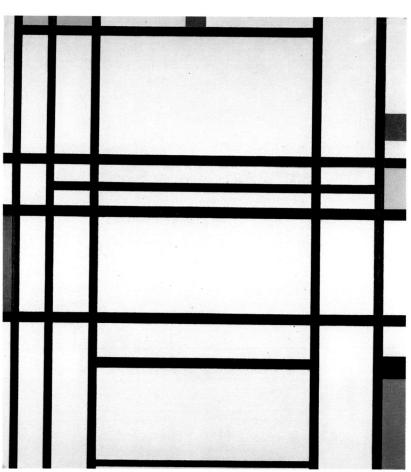

Piet Mondrian, 1872–1944 *Composition with Red, Yellow, and Blue*
1939–42 Oil on canvas 80 × 73cm

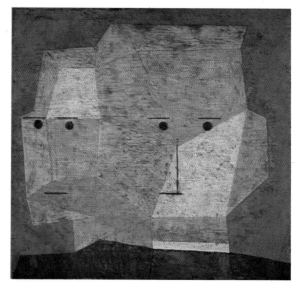

Paul Klee, 1879–1940 *Two Heads*
1932 Oil on canvas 80.8 × 84.7cm

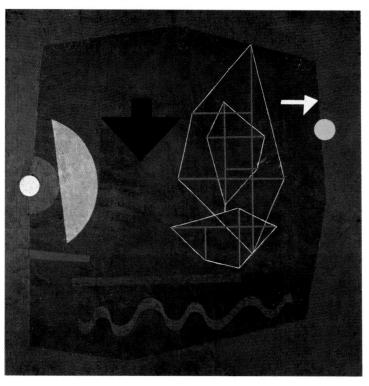

Paul Klee, 1879–1940 *Possibilities at Sea*
1932 Oil and sand on canvas 97.2 × 95.5cm

Index